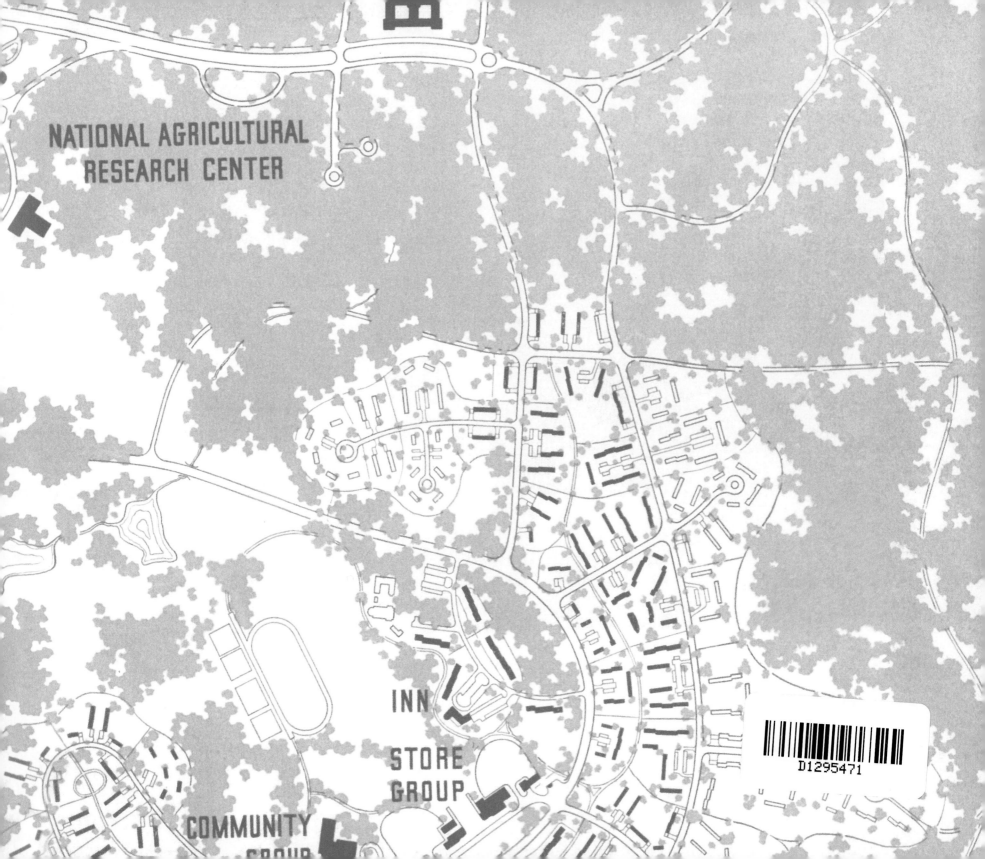

NATIONAL AGRICULTURAL
RESEARCH CENTER

INN

STORE
GROUP

COMMUNITY
GROUP

D1295471

NEW DEAL UTOPIAS

Jason Reblando

Jason Reblando

KEHRER

NEW DEAL UTOPIAS

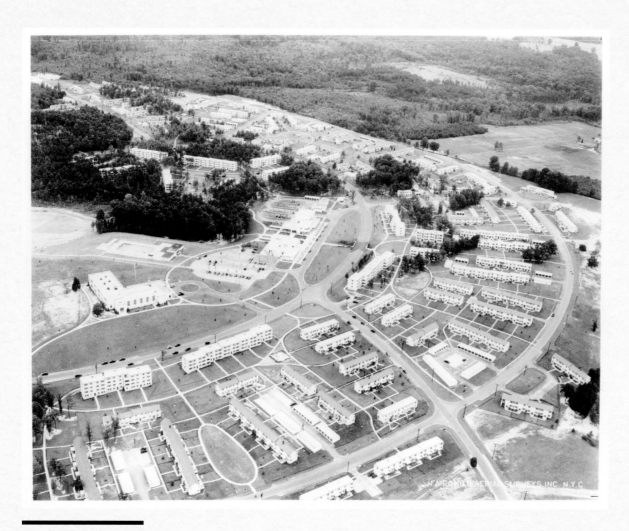

Greenbelt, Maryland, 1939,
Fairchild Aerial Survey

ENVISIONING
UTOPIA
NATASHA EGAN

"In the center of Fedora, that gray stone metropolis, stands a metal building with a crystal globe in every room. Looking into each globe, you see a blue city, the model of a different Fedora. These are forms the city could have taken if, for one reason or another, it had not become what we see today. In every age someone, looking at Fedora as it was, imagined a way of making it the ideal city, but while he constructed his miniature model, Fedora was already no longer the same as before, and what had been until yesterday a possible future became only a toy in a glass globe."
—Italo Calvino, *Invisible Cities*

In Italo Calvino's 1972 novel *Invisible Cities*, Marco Polo captivates the elderly emperor Kublai Khan with tales of fifty-five cities spread throughout the Khan's fading empire. The Khan relies on the young Venetian explorer to describe the state of his empire, but suspects that Polo may be deceiving him and that his cities may not in fact exist.

Similarly utopian aspirations of urban planning could be ascribed to America's Greenbelt Towns of the 1930s, which were developed as part of President Franklin D. Roosevelt's New Deal. A series of experimental projects and programs, the New Deal aimed to restore prosperity and self-respect to many Americans deeply affected by the Great Depression. For over three years, Jason Reblando turned his camera lens on the three Greenbelt Towns— Greenbelt, Maryland; Greenhills, Ohio; and Greendale, Wisconsin—that were constructed to provide work relief for the unemployed, provide affordable housing for low-income

families, and be a model for future town planning in America. Reblando's photographs, taken seventy-five years after the towns were built, point to how these idealistic visions have adapted or failed to adapt to changing circumstances. They challenge us to see beyond the physical attributes of a town's layout and to consider the consequences of design, in human terms.

Rexford Tugwell, a former economics professor at Columbia University, developed the Greenbelt Town program for the Roosevelt's Resettlement Administration (RA). Every facet of the Greenbelt Towns was an experiment in physical and social community planning. Town designs were based upon the Garden City movement of early twentieth-century England, combining the social and economic advantages of cities with the fresh air and open spaces of the country. Tugwell's more ambitious and controversial goal for the Greenbelt program was to usher in a whole new American

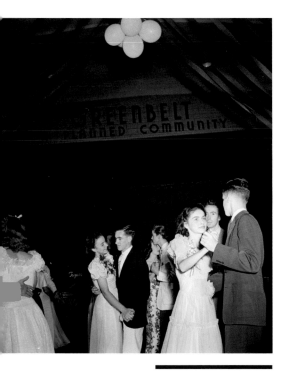

Senior prom in Greenbelt, Maryland, 1942

way of life in the form of a more cooperative and egalitarian society.[1]

Conservative members of Congress, industrial and corporate leaders, and newspapers hostile to New Deal policies viewed the publicly funded program as government folly. They lambasted Tugwell and his desire for cooperative communities as socialist and communist. However, Tugwell believed Greenbelt Towns to be a social and economic antidote for hard times caused by the Great Depression. Shared courtyards and intersecting walkways were designed to encourage social cohesion among the residents. The schools, shops, and community buildings were run cooperatively. Collectively, the residents reflected a social experiment in demographic diversity, as the RA handpicked each family who lived there to bring together a cross section of income levels and religious beliefs, as well as people the RA believed would make positive contributions to the community. Notably, even though many African Americans helped build the Greenbelt Towns, racial integration was not considered in populating them. Greenbelt, Maryland, for example, was exclusively white until the 1950s.[2]

As criticism of RA programs mounted, Tugwell recruited one of his former graduate assistants at Columbia University, Roy Stryker, to create visual evidence that poor Americans needed help, and that New Deal programs were

providing it. Stryker became head of the Historical Section of the Information Division of the RA, a staff of over forty photographers, all tasked with representing the interests of the RA, which was later folded into the Department of Agriculture and renamed its more familiar title, the Farm Security Administration (FSA). The FSA photographers are mostly known for depicting the United States' impoverished conditions, highlighted by two well-known images from 1936, Dorothea Lange's *Migrant Mother* and Walker Evans's photograph of a sharecropper's poverty-stricken wife staring into his camera. However, they also portrayed a country bound for recovery, including photographs capturing the formerly unemployed returning to work and positive portrayals of the newly constructed Greenbelt communities. Pictures demonstrating the egalitarian nature of the Greenbelt program—rows of newly built houses with curved sidewalks and common lawns—are combined with photographs of families going for walks, relaxing on lawn chairs, swimming in the neighborhood pool, shopping at the cooperative grocery store, and playing baseball in the park, each portraying a safe and livable community. However, in the end, with the rise of fascism and communism spreading across Europe, Tugwell's cooperative ideology became a political lightning rod for Roosevelt, and Tugwell resigned from the RA at the end of 1936. By 1954, the Greenbelt communities transferred their federal ownership to their occupants and private real estate developers, and each suburb has evolved with changing economic needs and demographics over the decades.[3]

1 Jason Reblando, "Farm Security Administration Photographs of Greenbelt Towns: Selling Utopia During the Great Depression," in: *Utopian Studies* 25.1 (2014), pp. 52–86.
2 Ibid.
3 Ibid.

Harkening back to the FSA photographs depicting the Greenbelt Towns, Jason Reblando's photographs explore the intersections of the towns' complex histories and politics as well as the varied sense of place they evoke today. Using a straightforward documentary approach with formal rigor, Reblando photographs the green spaces, housing developments, and communal activities of the three communities, continually connecting the natural world and the built environment. A photograph of three filing cabinets with the town's original blueprints hanging off-center and reflecting the fluorescent office lights is at once pristine and imperfect. In *Daffodil House*, a curtain of leaves frames a row of modest houses, one of which has an ornamental flower on its chimney, as if announcing its individuality in a town whose values were founded not only on egalitarianism, but also order. Another photograph, made entirely green from the grassy parkway and density of trees, depicts a pedestrian underpass, alluding not only to safe passage for walkers but also to a designed harmony between residents and nature. A picture of a slightly rundown water feature in the center of a community swimming pool under a romantic evening sky implies that even idylls must age. The scarcity of people in Reblando's photographs leads viewers to ask: What role does the actual human experience play in utopian plans? In Reblando's words, these photographs of Greenbelt, Greenhills, and Greendale "are an opportunity to engage with a unique expression of the New Deal as we continue to grapple with the complexities of housing, nature, and government

in contemporary American life."[4] Particular notions of an ideal society—"utopia"—often inform an urban plan. Utopias are places where collective dreams of peace and harmony are realized. But happiness is not necessarily a place. Each of these towns was created from plans that oftentimes reflected the interests of politicians, and not the realities of the inhabitants. Jason Reblando's pictures portray not a utopia so much as the questions that surround Tugwell's attempt to create one. An ideal, intrinsically unobtainable, is guaranteed to disillusion. Although the Greenbelt plans endeavored to have a profound impact on a town's society—and arguably did—they were only a glimpse of Tugwell's dream of remaking America.

Cities, even Greenbelt Towns, can be tenuous places. As Calvino's Marco Polo describes the city of Thekla to Kublai Khan:

Those who arrive at Thekla can see little of the city, beyond the plank fences, the sack-cloth screens, the scaffoldings, the metal armatures, the wooden catwalks hanging from ropes or supported by sawhorses, the ladders, the trestles. If you ask, "Why is Thekla's construction taking such a long time?" the inhabitants continue hoisting sacks, lowering leaded strings, moving long brushes up and down, as they answer, "So that its destruction cannot begin." And if asked whether they fear that, once the scaffoldings are removed, the city may begin to crumble and fall to pieces, they add hastily, in a whisper, "Not only the city."[5]

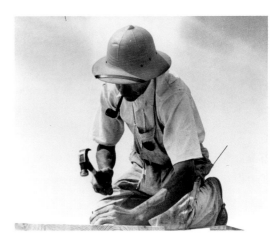

Carpenter in Greenbelt, Maryland, 1936

4 Jason Reblando, *New Deal Utopias* project statement emailed to author, February 11, 2014.
5 Italo Calvino, *Invisible Cities*, trans. William Weaver (San Diego; New York, and London: Harcourt, Inc., 1974), p. 127. Originally published as: *Le città invisibili* (Turin: Giulio Einaudi Editore, 1972).

" **I have gathered my tools and my charts;**
My plans are fashioned and practical;
I shall roll up my sleeves—*make America over!* "

Rexford Tugwell,
"The Dreamer,"
Intercollegiate magazine,
University of Pennsylvania, 1915

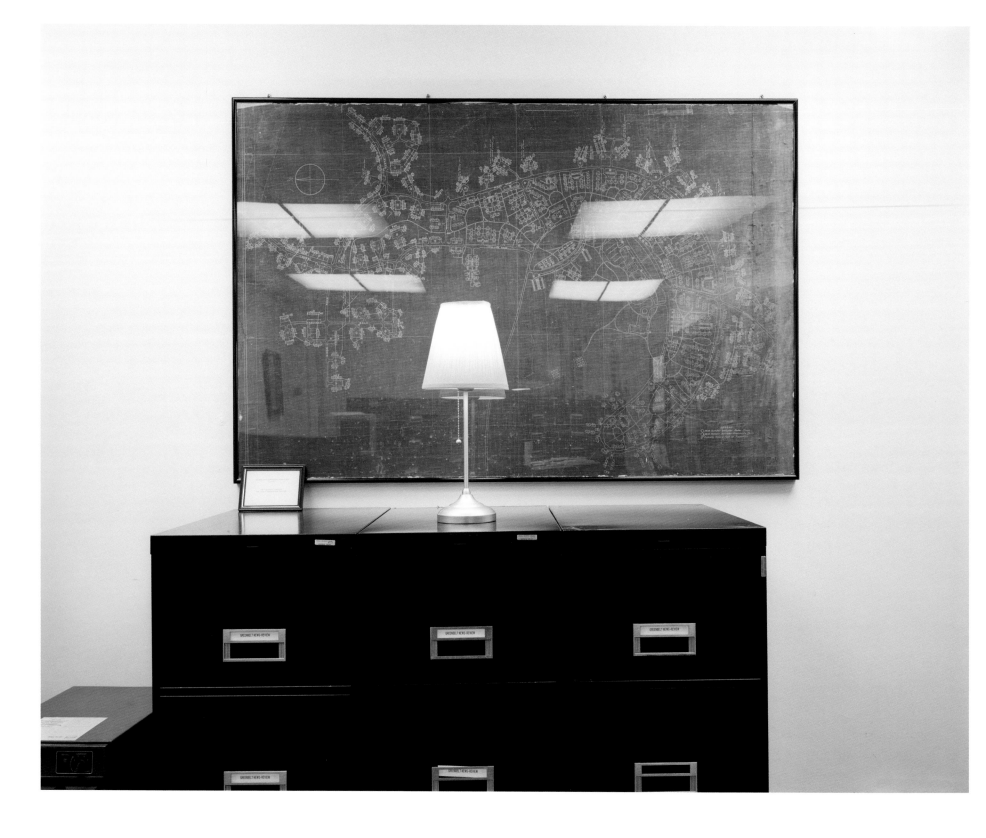

Blueprint
GREENBELT, MARYLAND

Daffodil House
GREENDALE, WISCONSIN

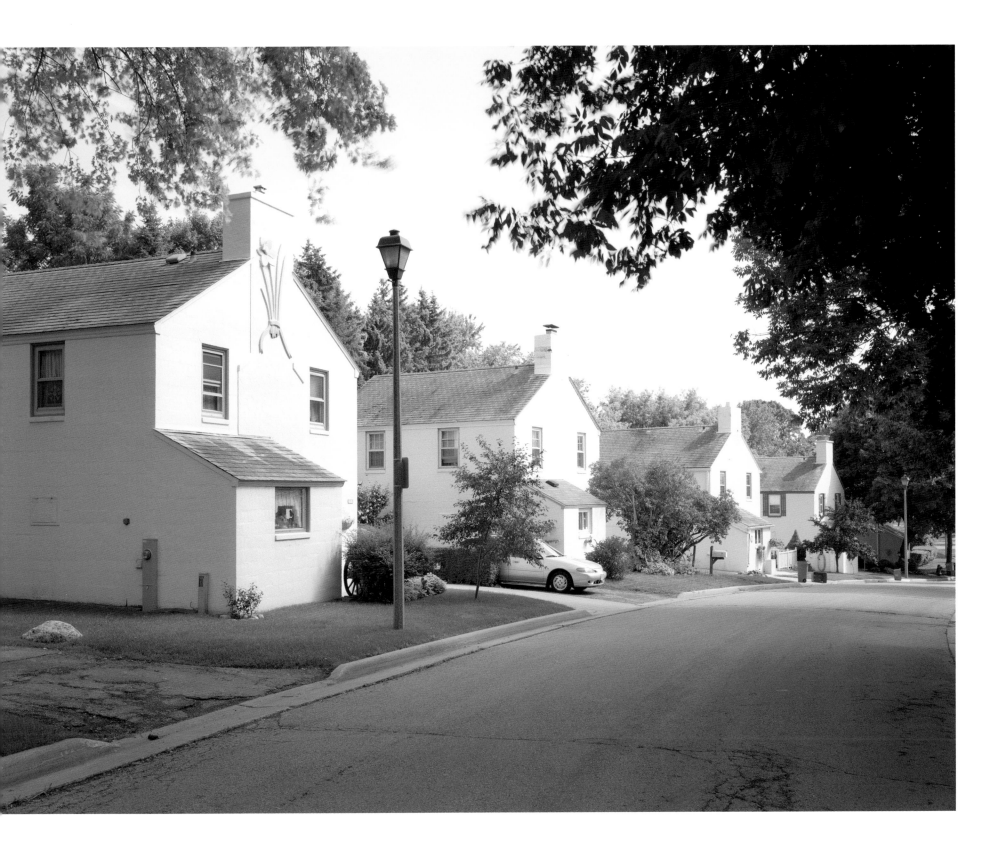

Frieze
GREENBELT, MARYLAND

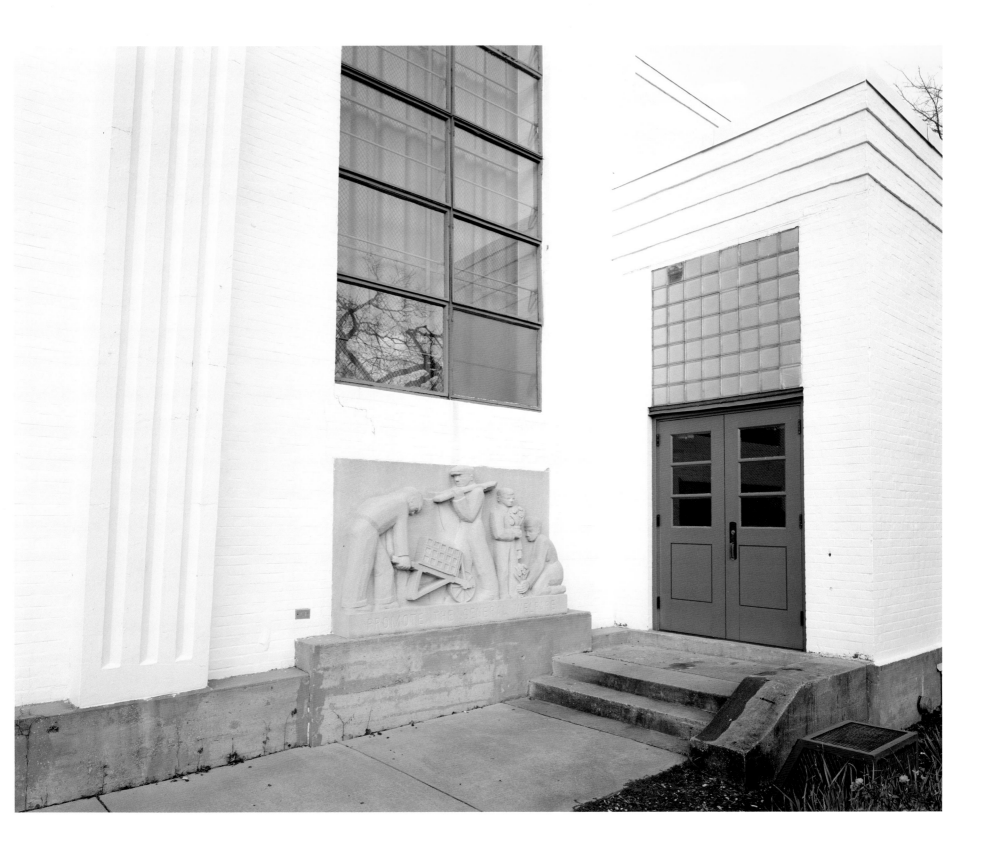

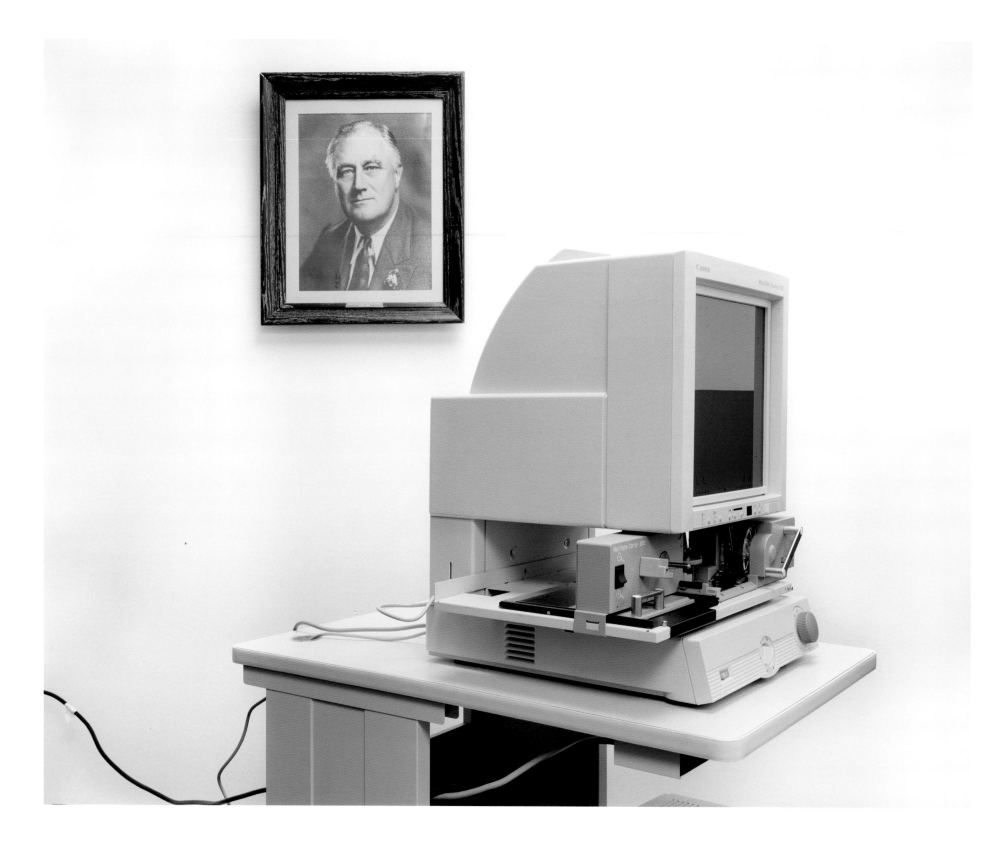

Microfiche
GREENBELT, MARYLAND

Roosevelt Baseball Players
GREENBELT, MARYLAND

Winton Woods
GREENHILLS, OHIO >

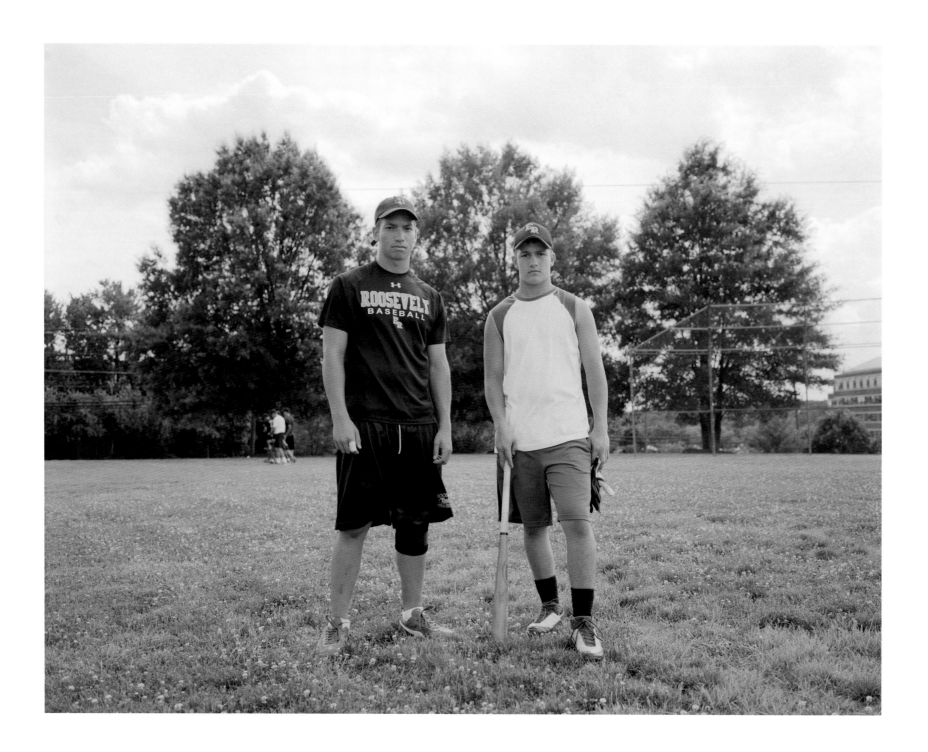

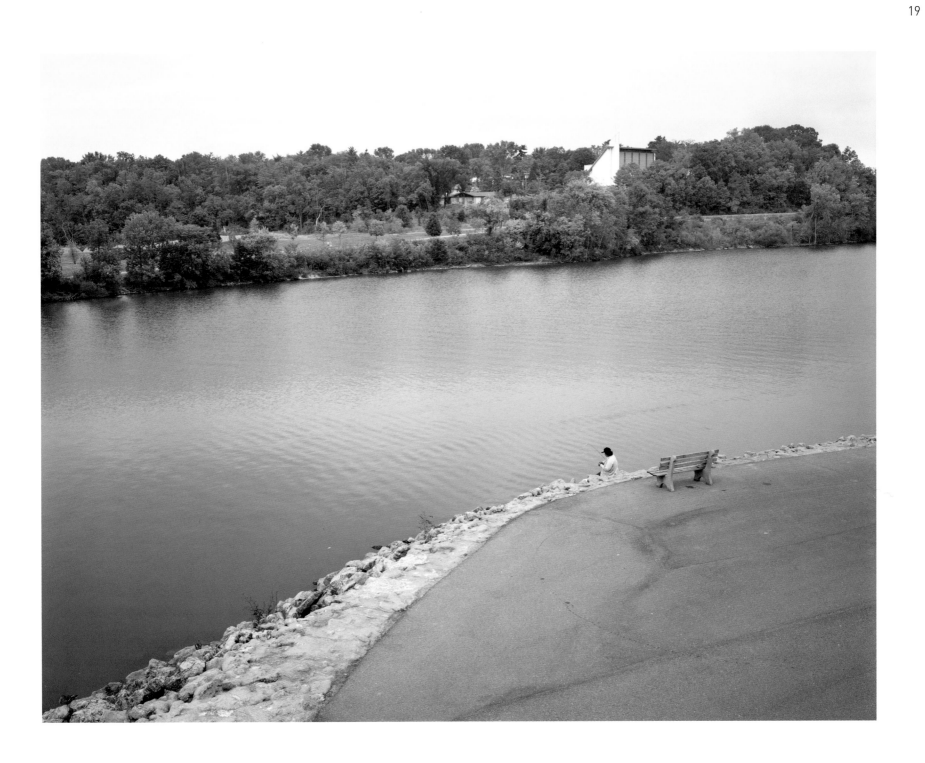

Mushroom
GREENBELT, MARYLAND

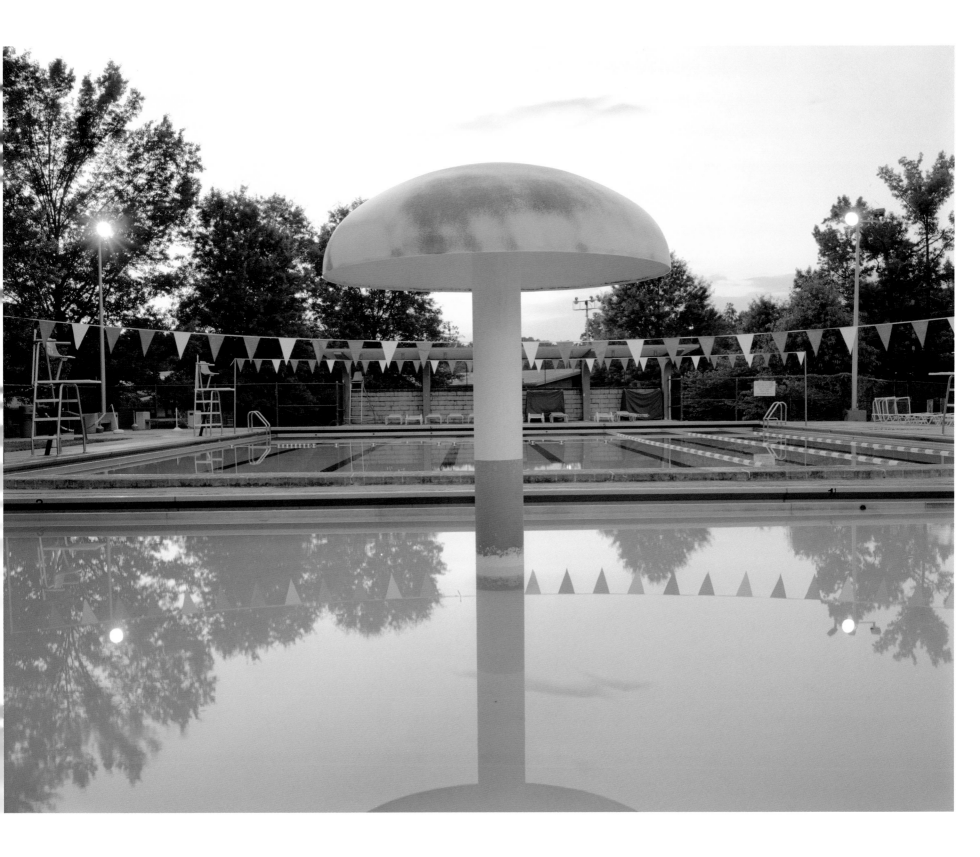

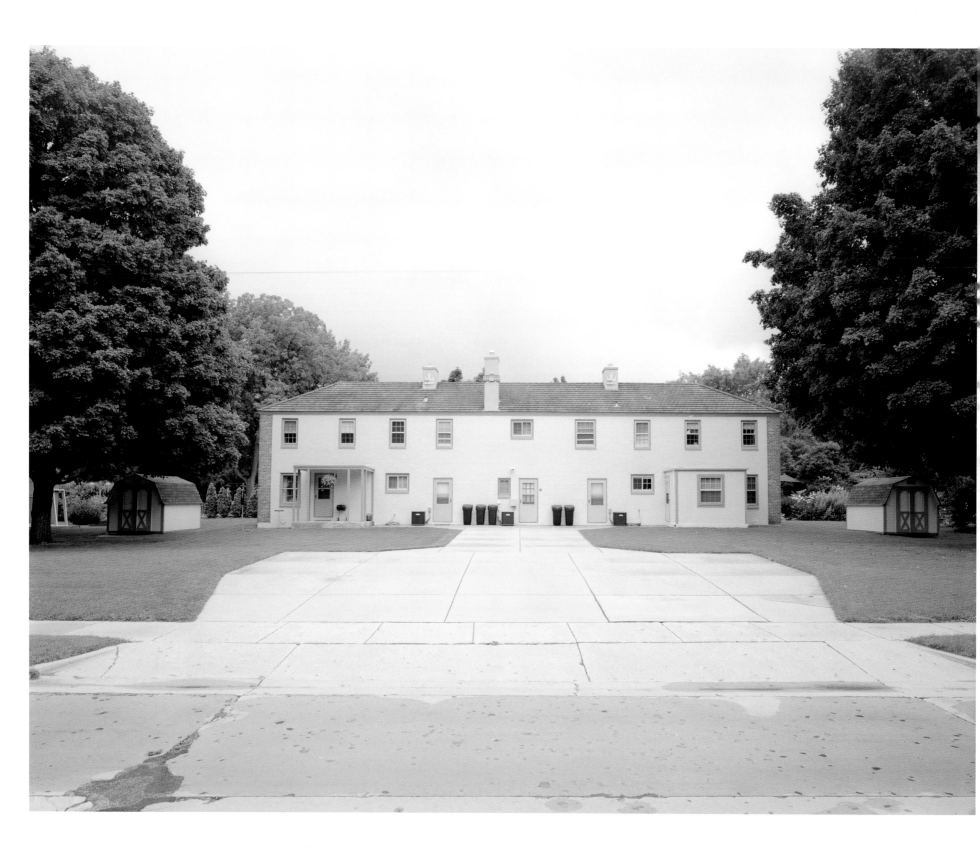

Townhouse
GREENDALE, WISCONSIN

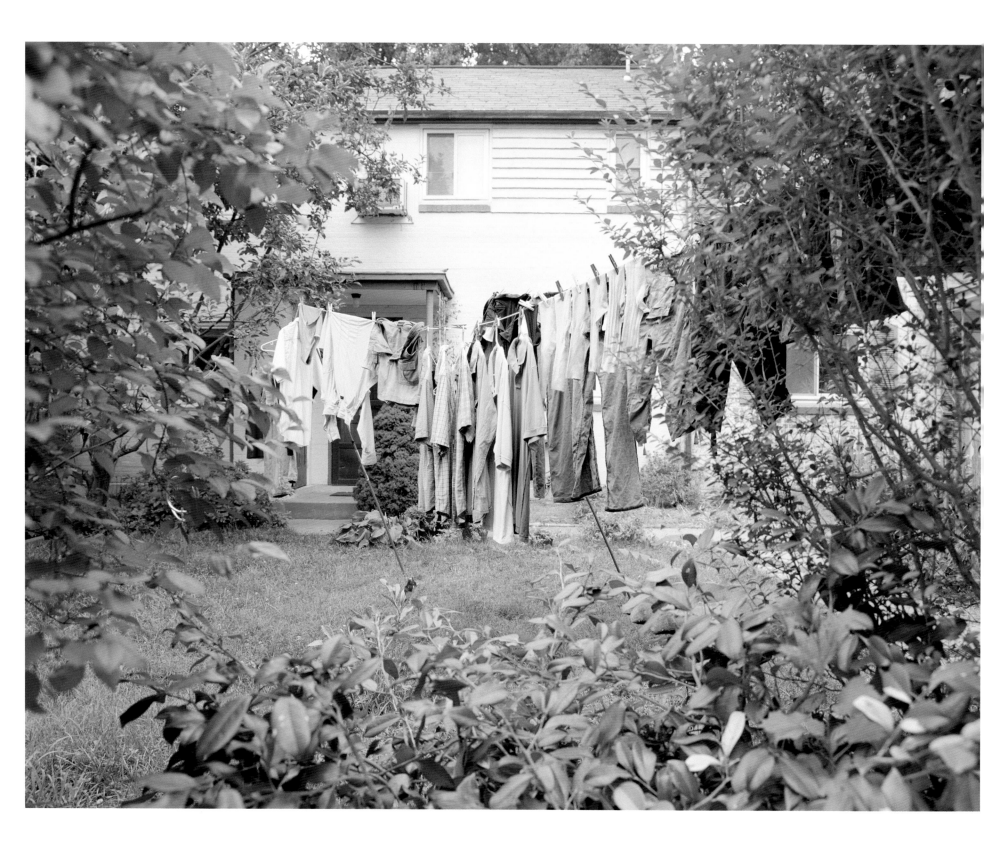

Clothesline
GREENBELT, MARYLAND

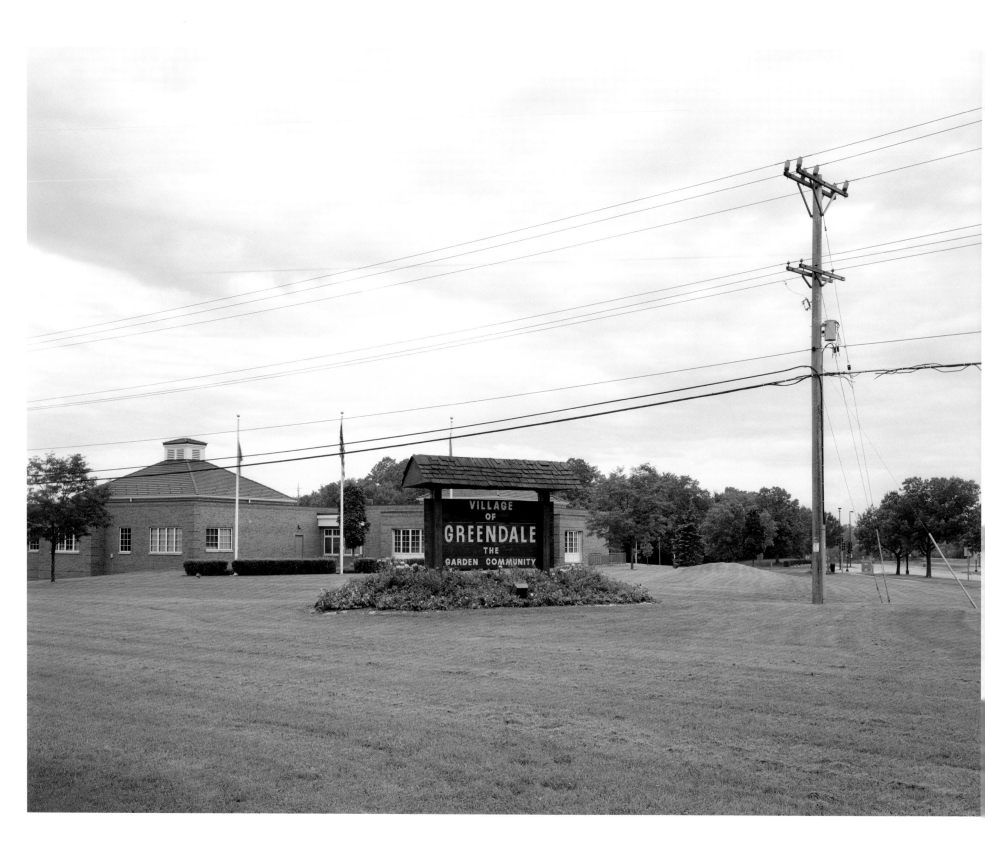

Garden Community
GREENDALE, WISCONSIN

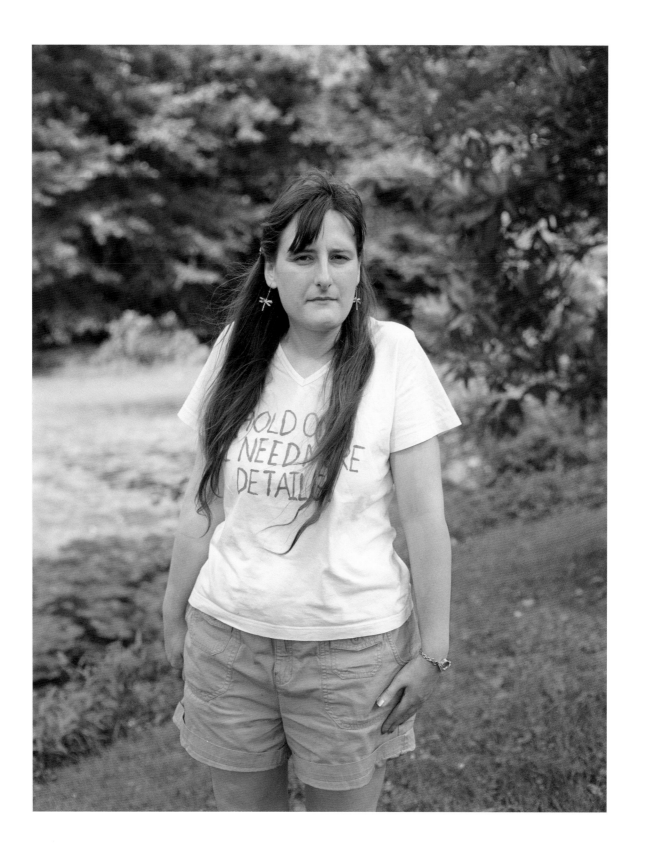

More Details
GREENBELT, MARYLAND

" **HUMAN SOCIETY** and the beauty of nature are meant to be enjoyed together.... Town and country *must be married*, and out of this joyous union will spring a new hope, and new life, a new civilization. "

SIR EBENEZER HOWARD,
Garden Cities of To-Morrow, 1902

Gazebo
GREENDALE, WISCONSIN

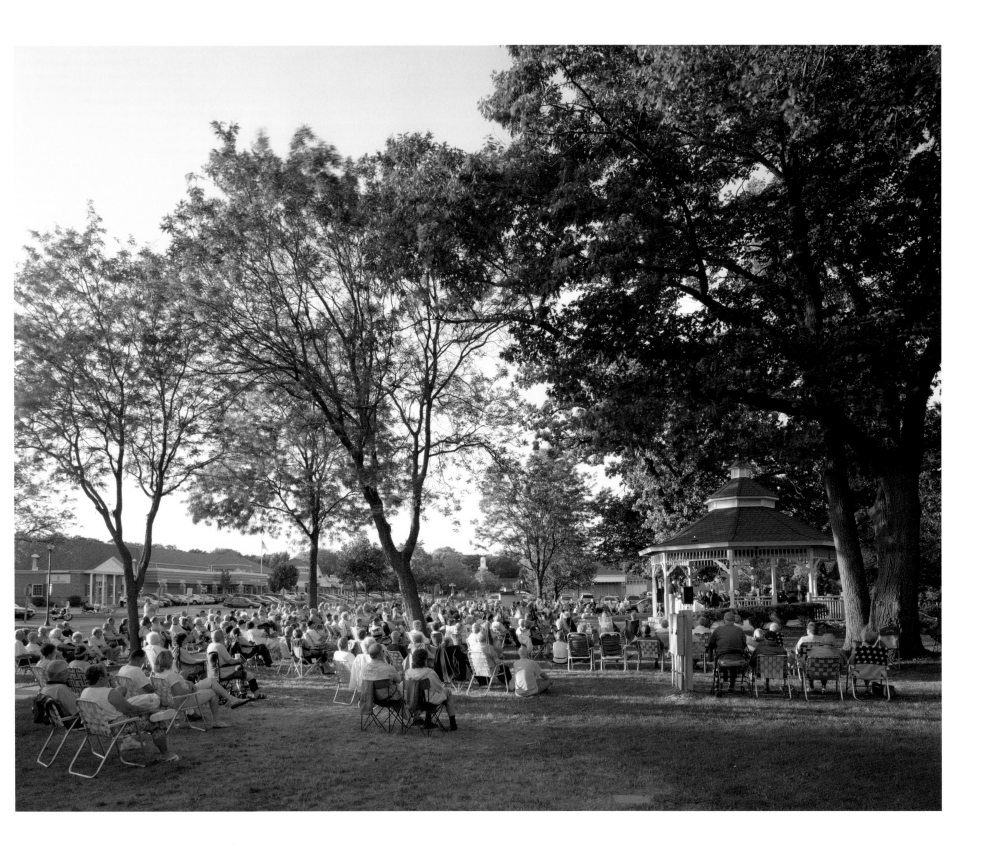

Tree Shade
GREENBELT, MARYLAND

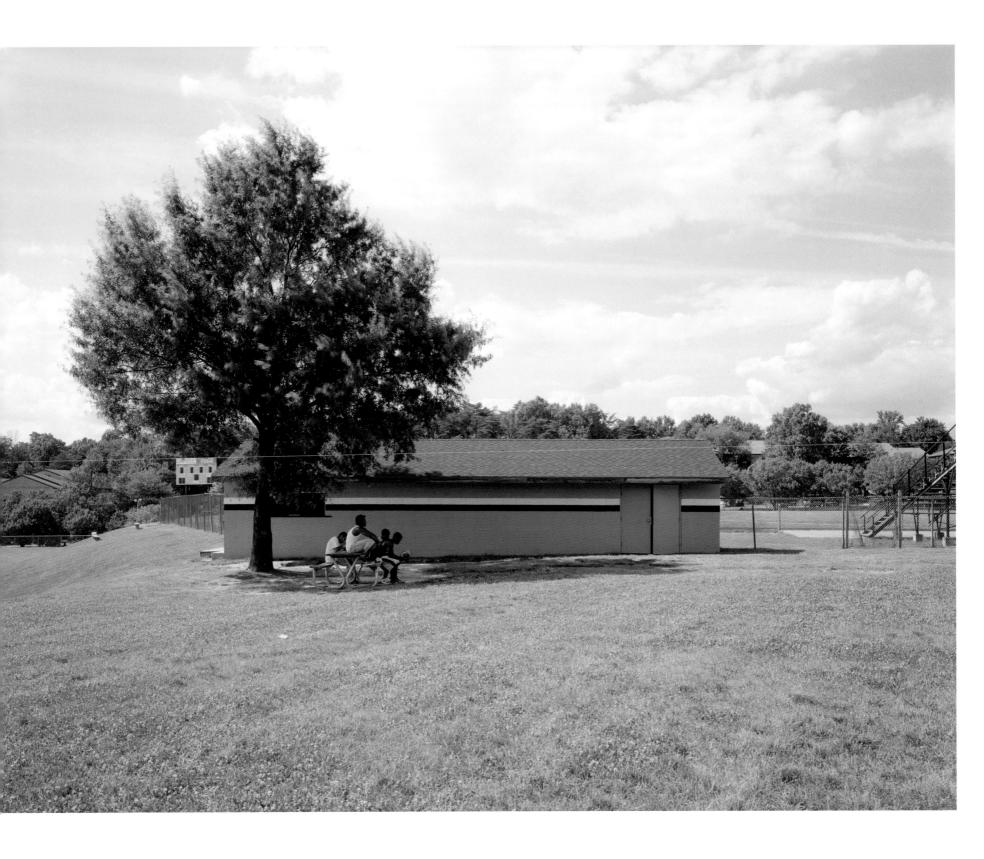

Underpass
GREENBELT, MARYLAND

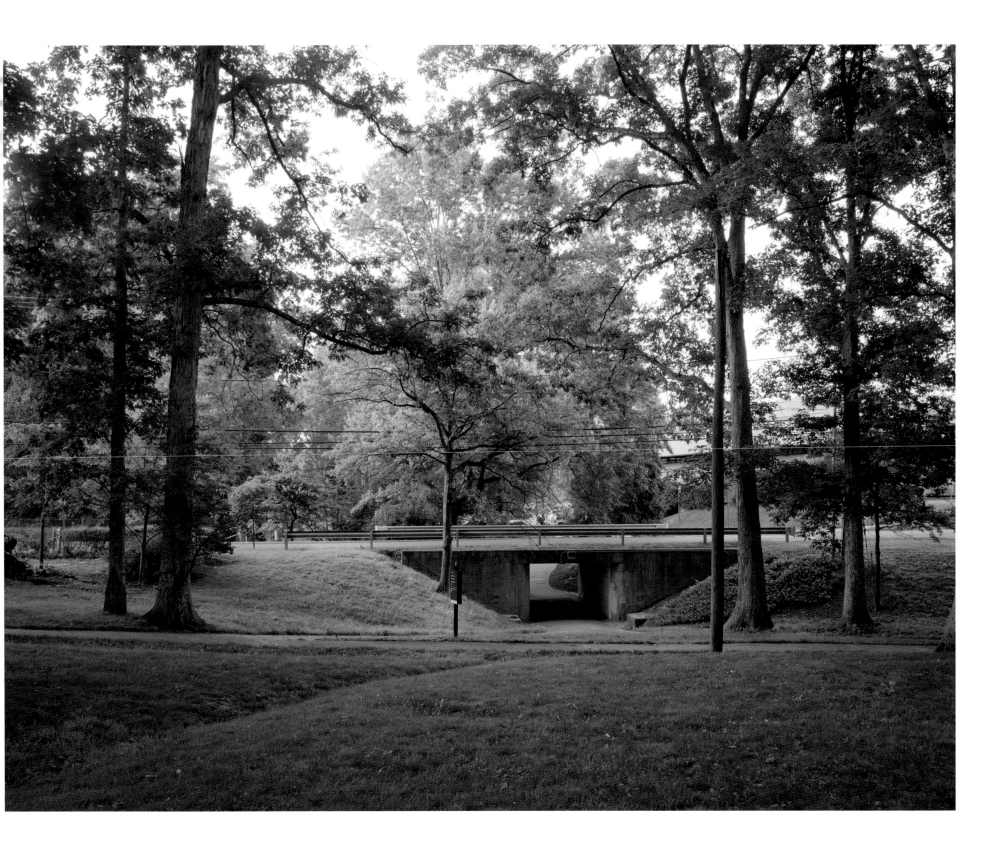

Farragut House
GREENHILLS, OHIO

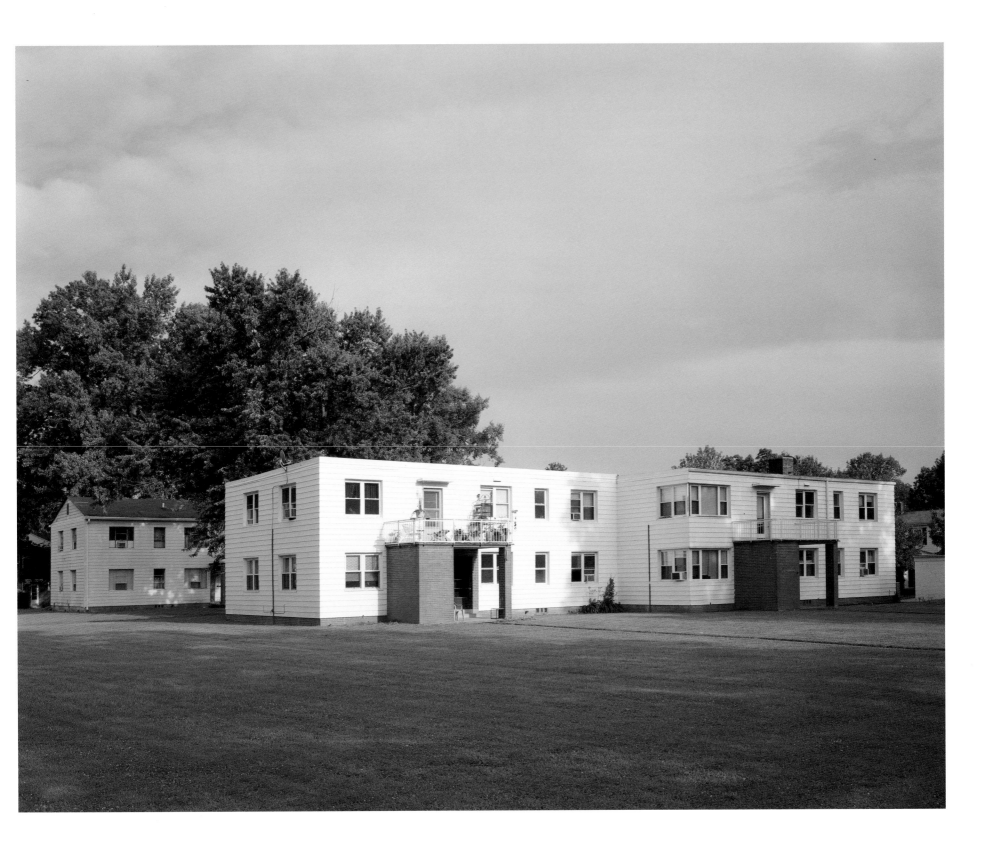

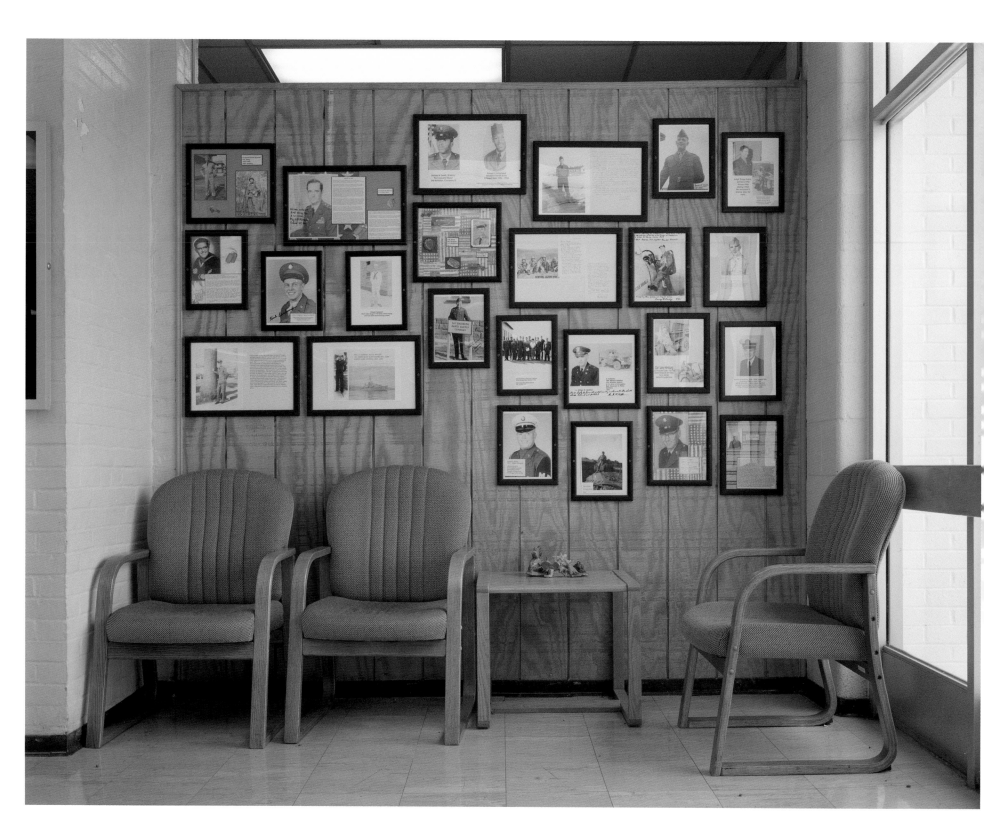

Veteran Pictures
GREENHILLS, OHIO

Greenbelt Lake
GREENBELT, MARYLAND

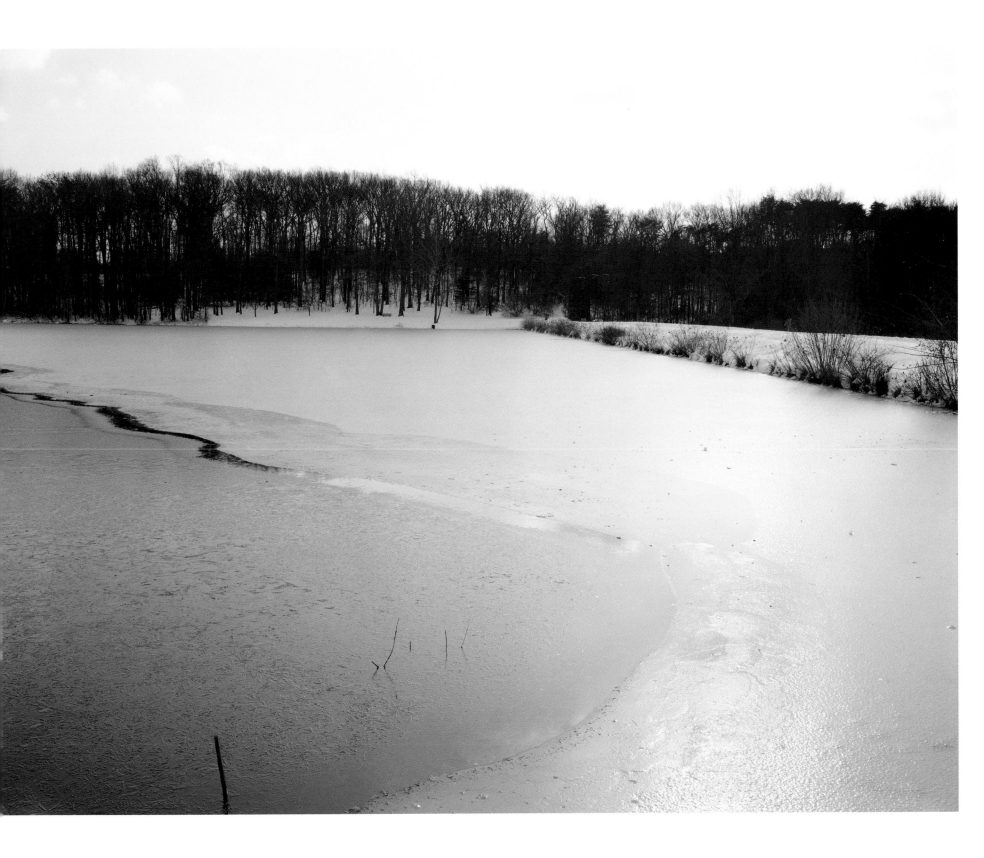

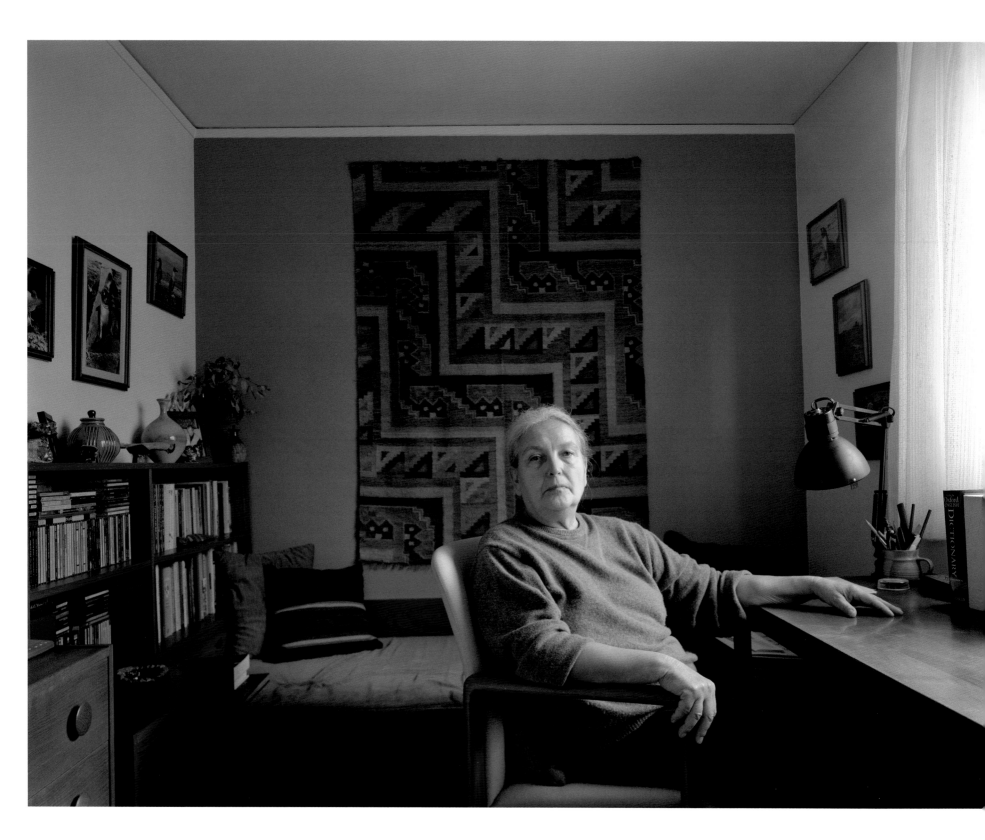

Woman in Study
GREENBELT, MARYLAND

City Hall
GREENBELT, MARYLAND

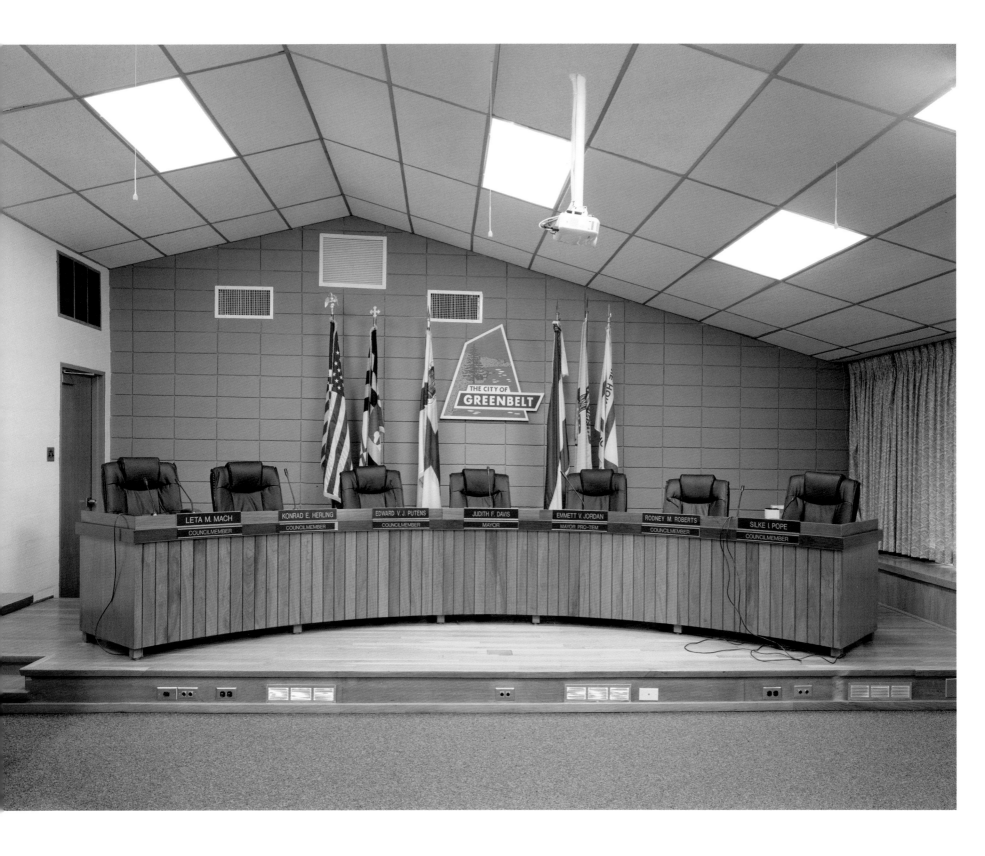

Wheat Room
GREENDALE, WISCONSIN

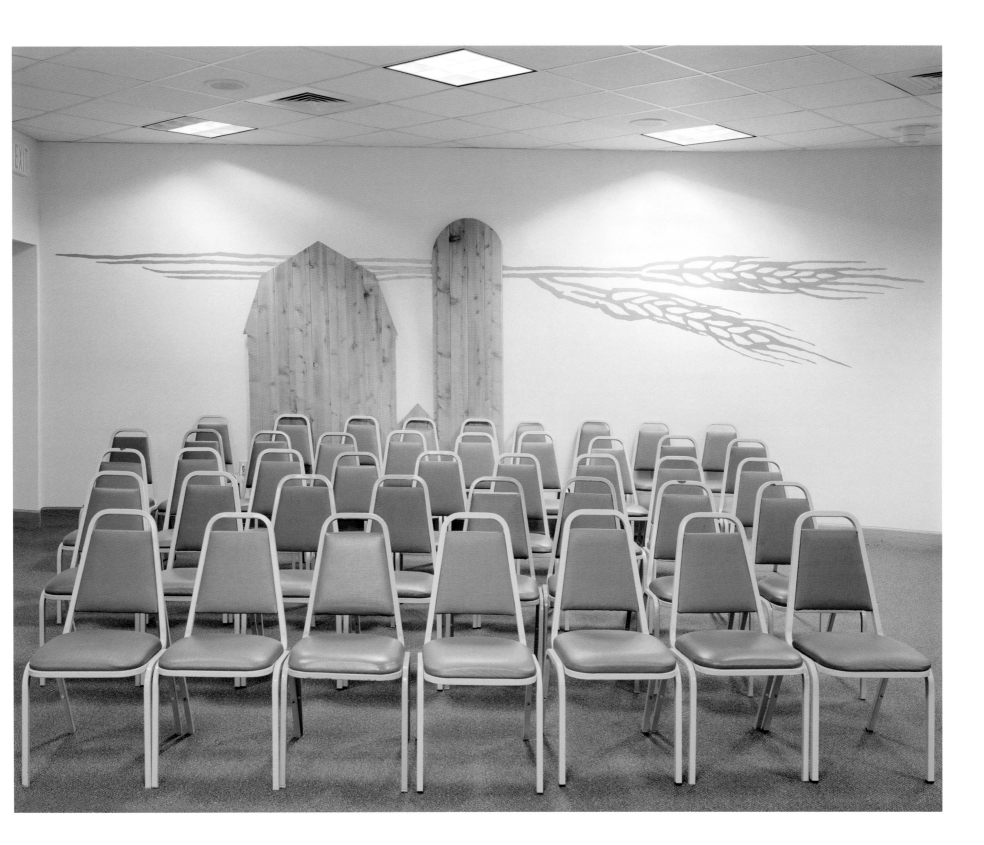

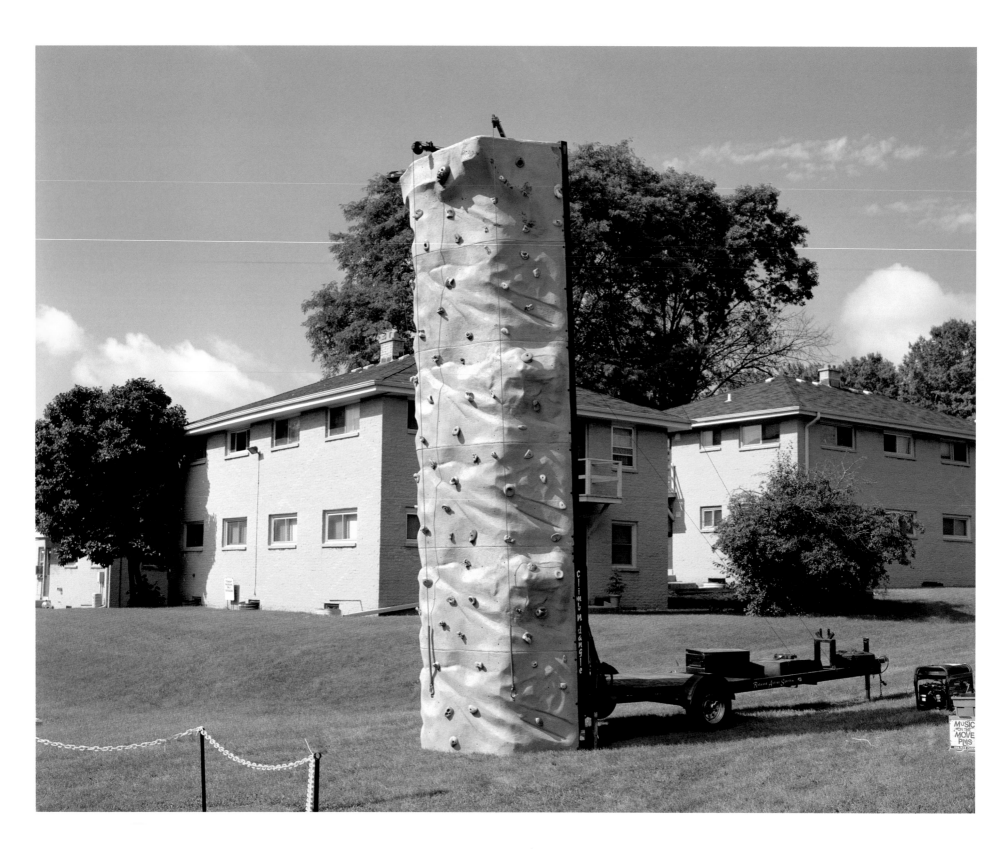

Rockclimb
GREENDALE, WISCONSIN

Living Room Garden
GREENBELT, MARYLAND

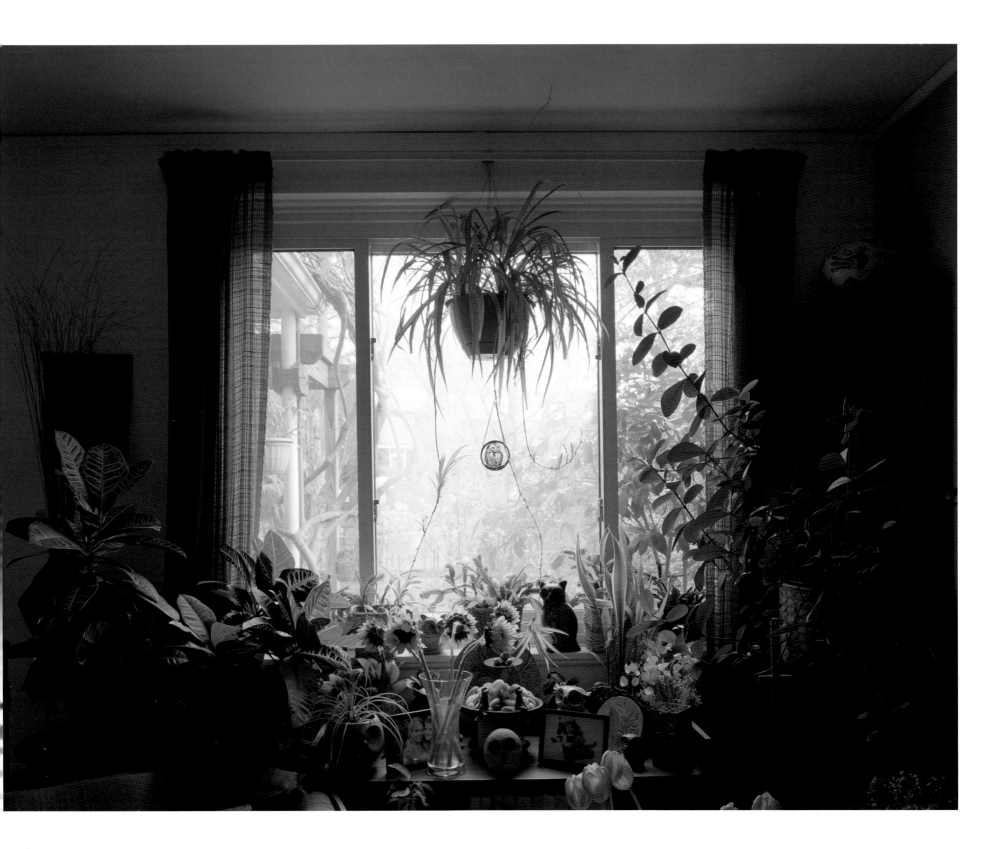

" **Paradise,**
Now nearer, Crowns with her enclosure green... "

———————————

John Milton,
Paradise Lost, 1667

Garden Cloth
GREENBELT, MARYLAND

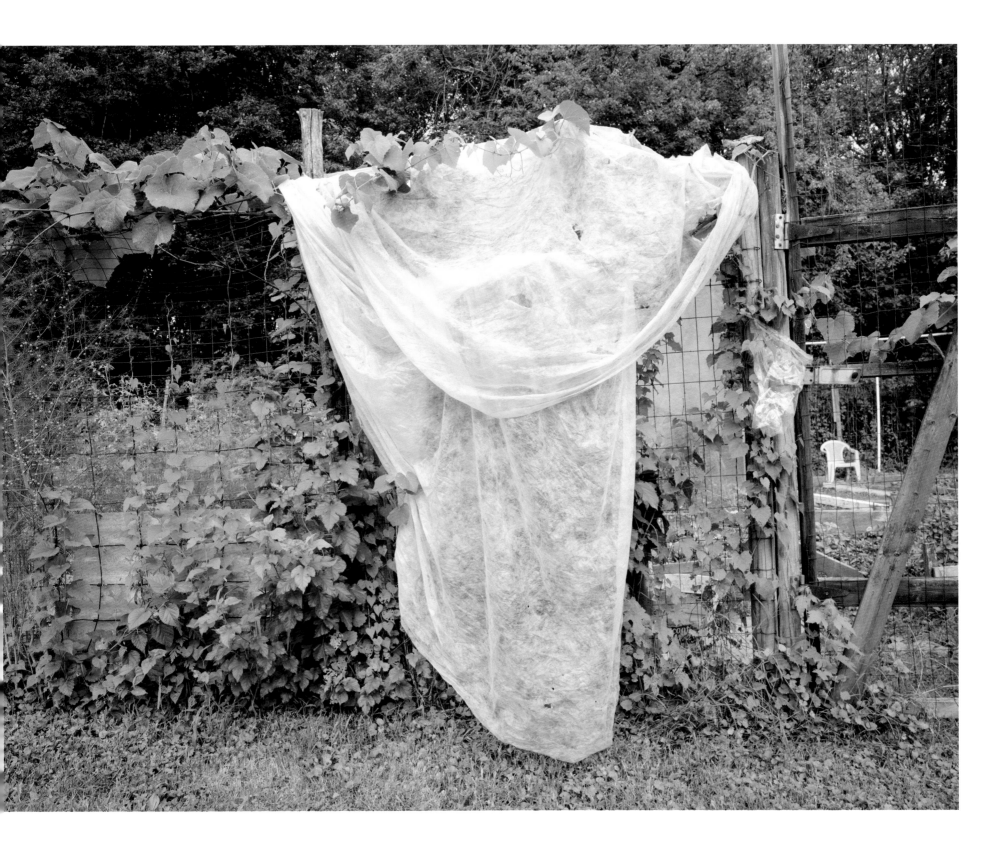

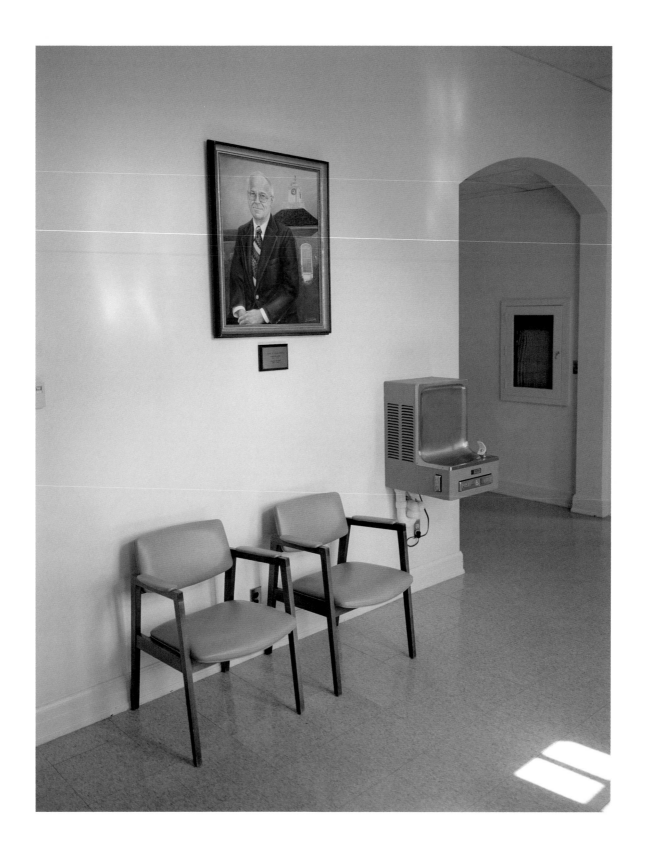

Village Hall
GREENDALE, WISCONSIN

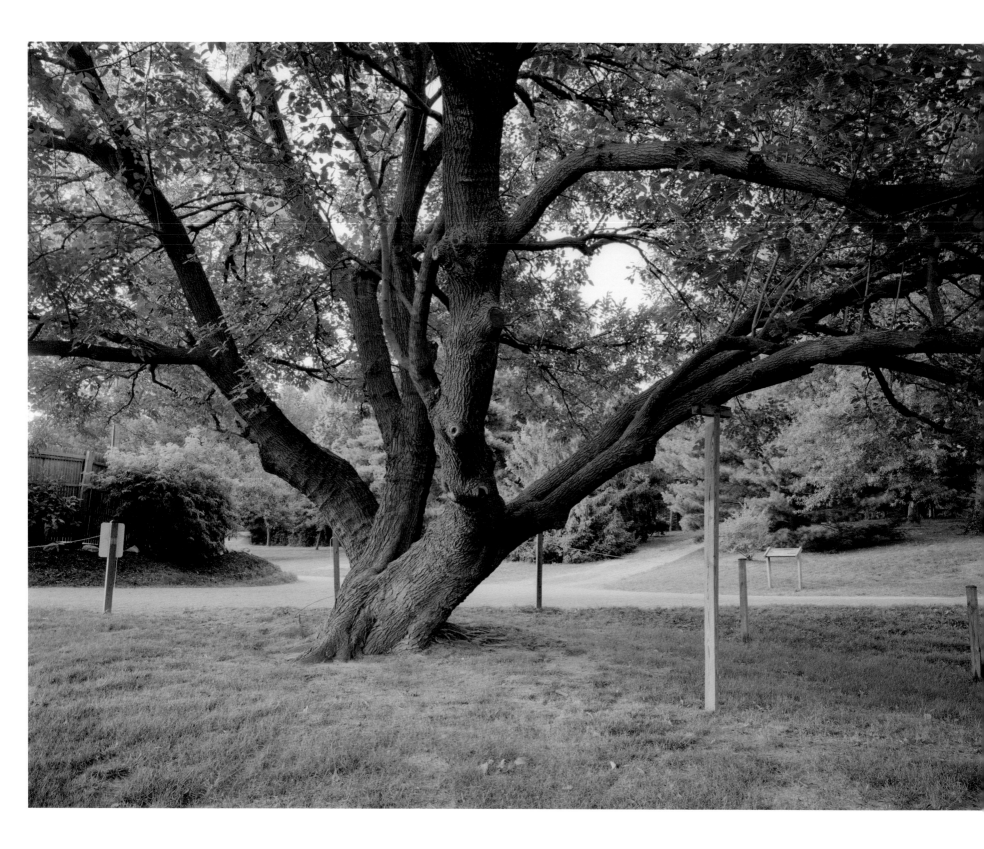

Tree Crutch
GREENBELT, MARYLAND

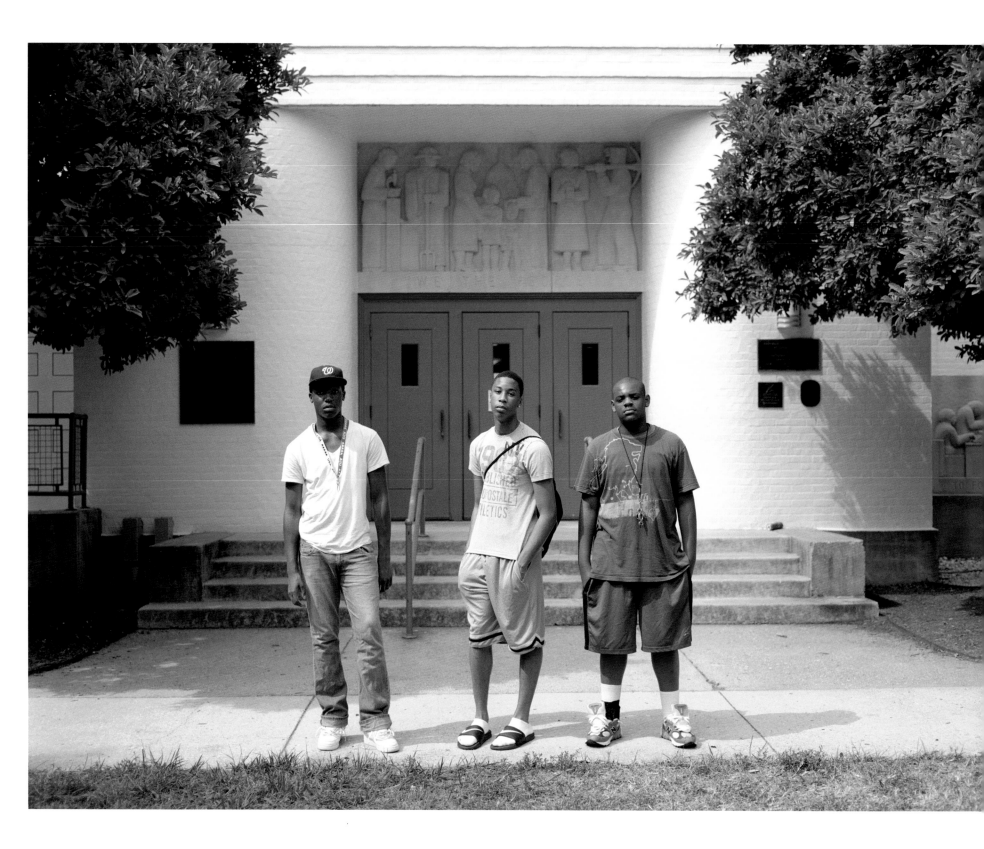

Teens in Front of Community Center
GREENBELT, MARYLAND

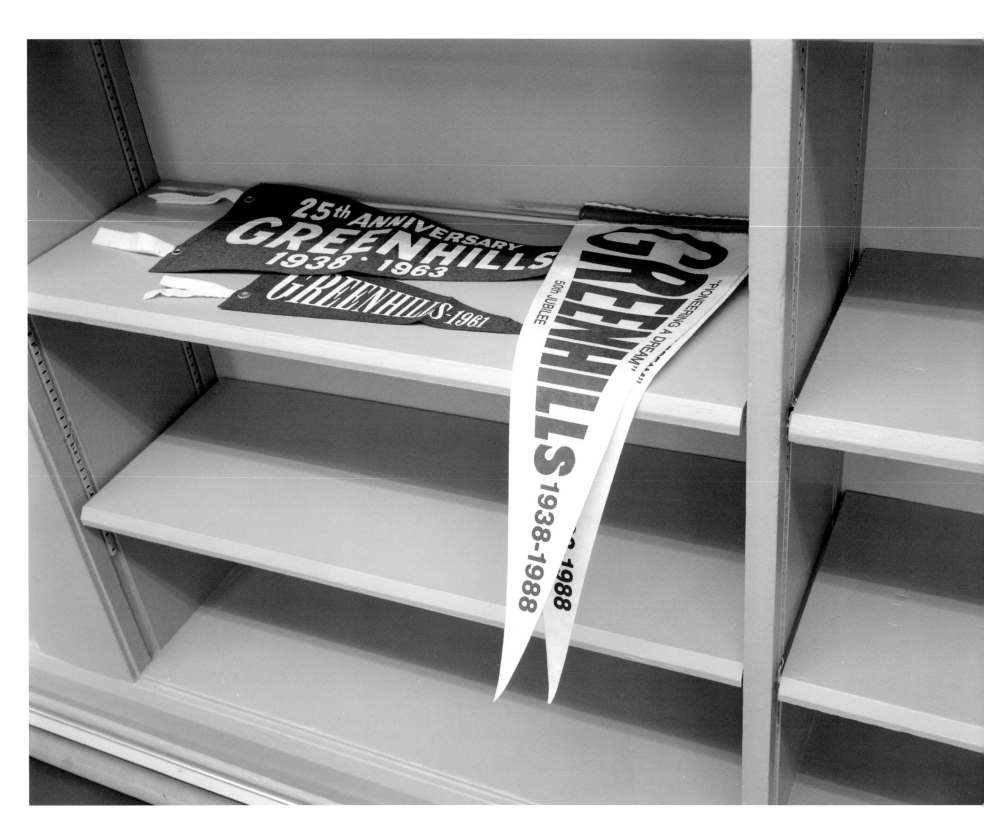

Anniversary Pennants
GREENHILLS, OHIO

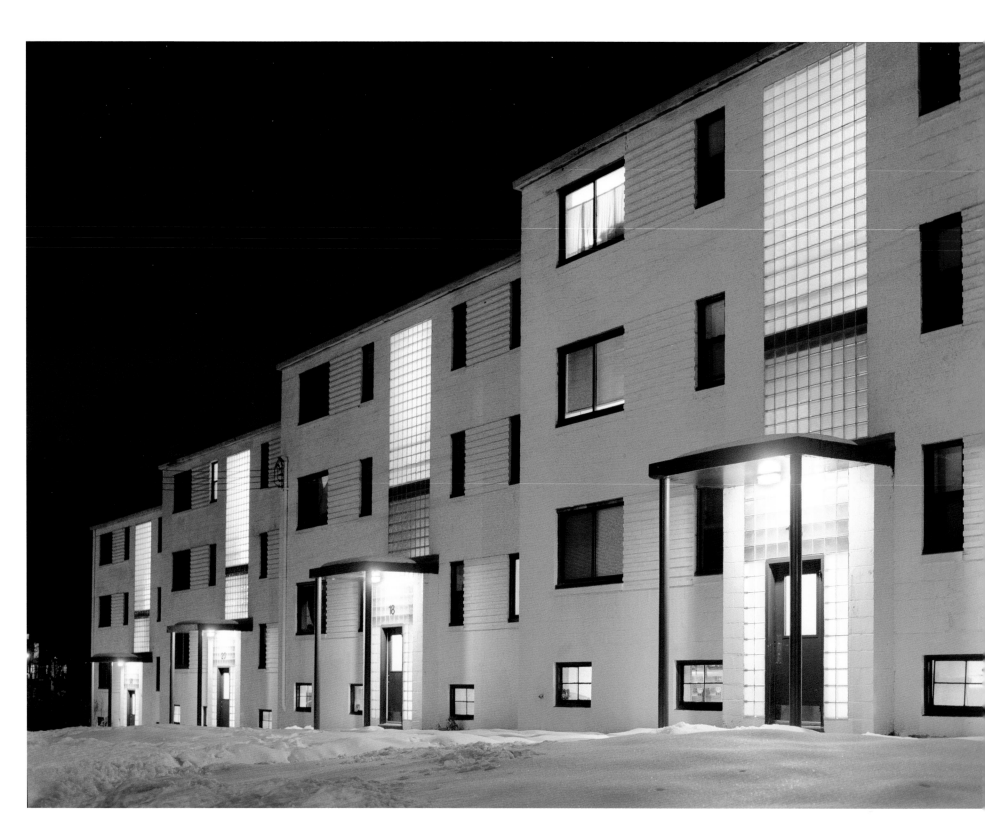

Glass Block Houses
GREENBELT, MARYLAND

Car Cover
GREENBELT, MARYLAND

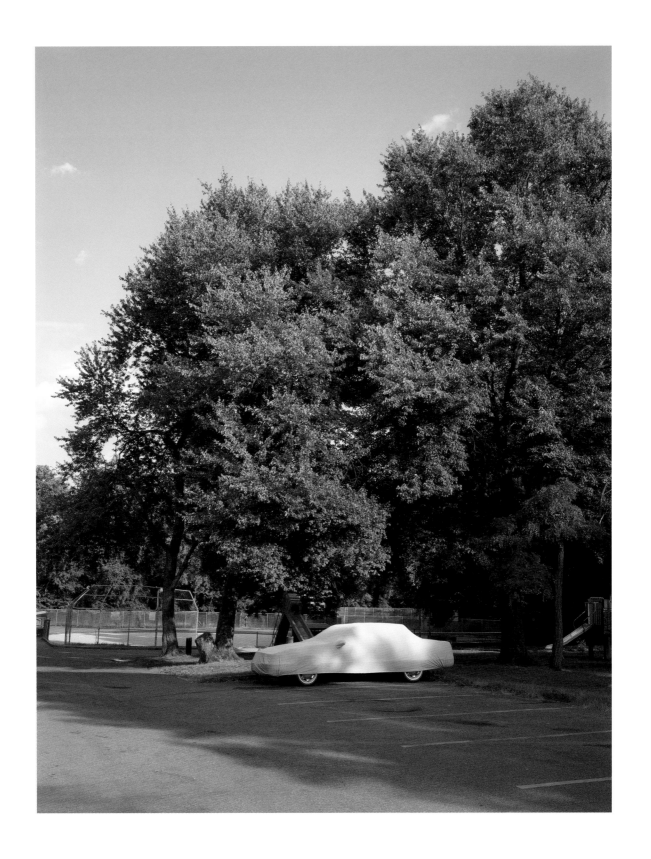

Basketball Court
GREENHILLS, OHIO

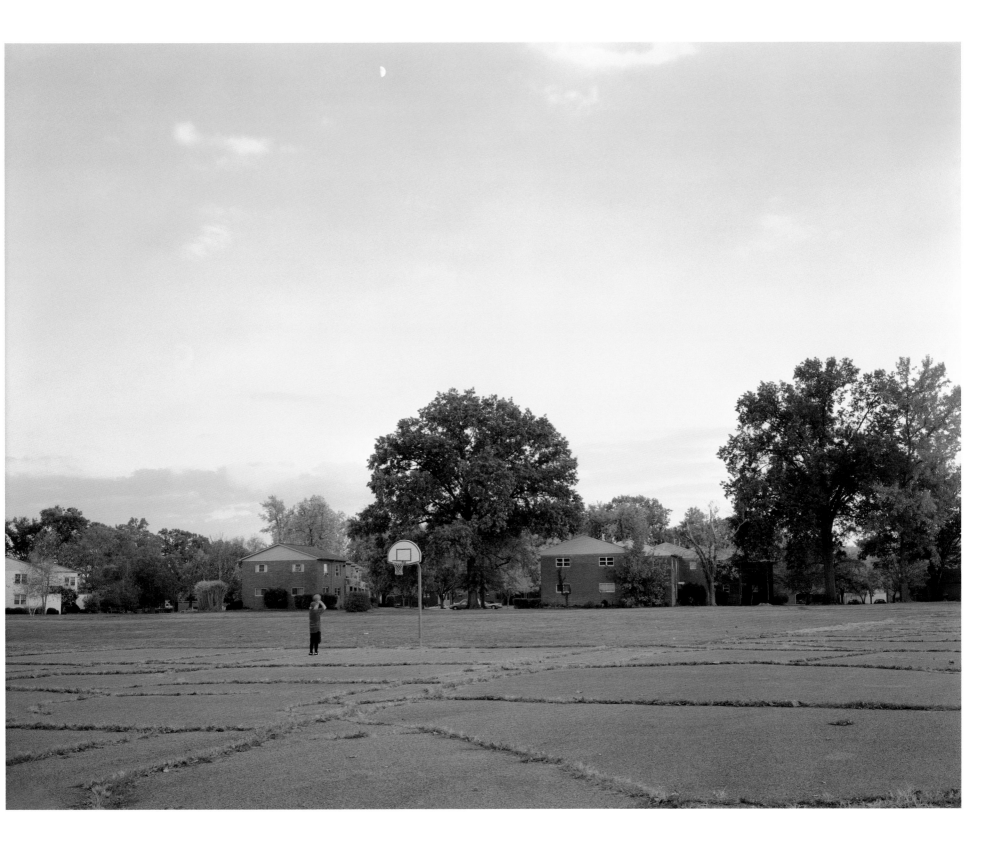

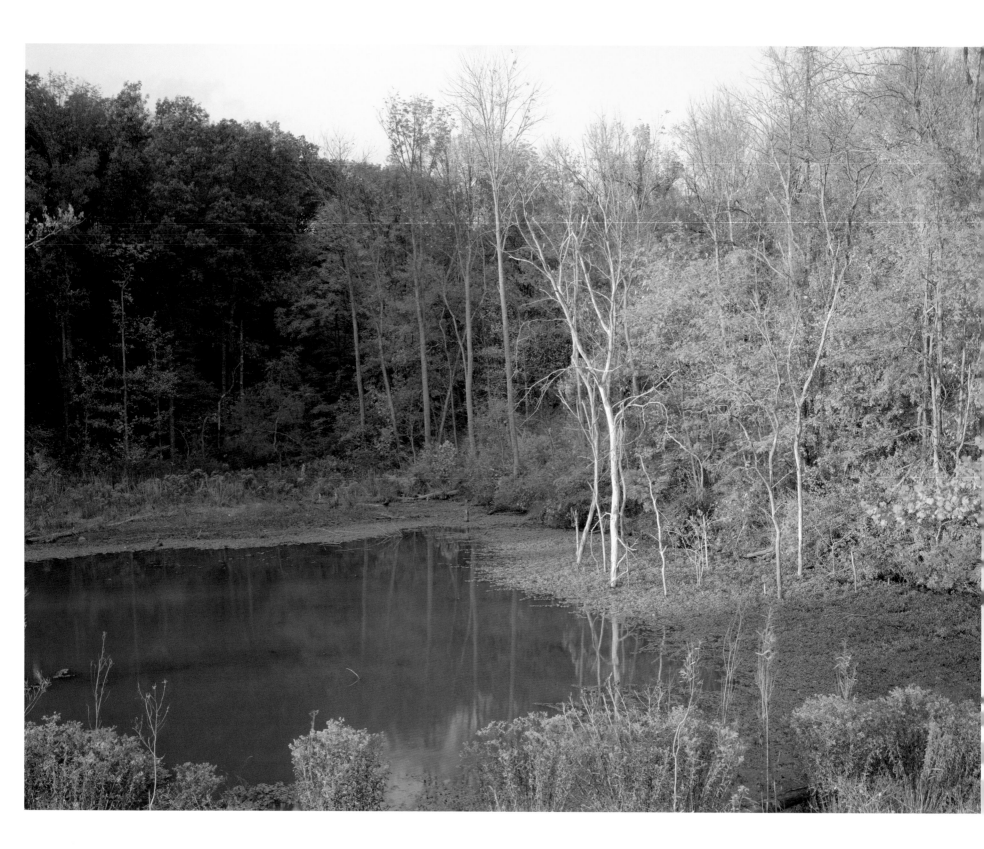

Lake
GREENHILLS, OHIO

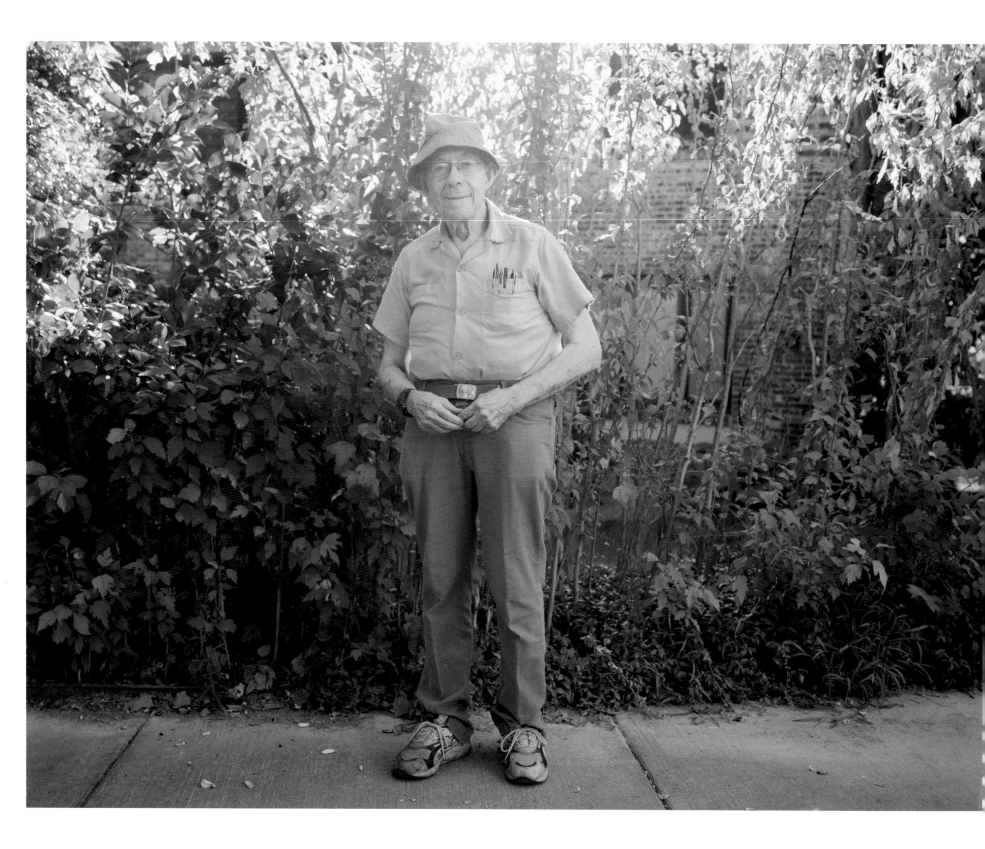

Man with Pocket Protector
GREENBELT, MARYLAND

Archery Target
GREENHILLS, OHIO

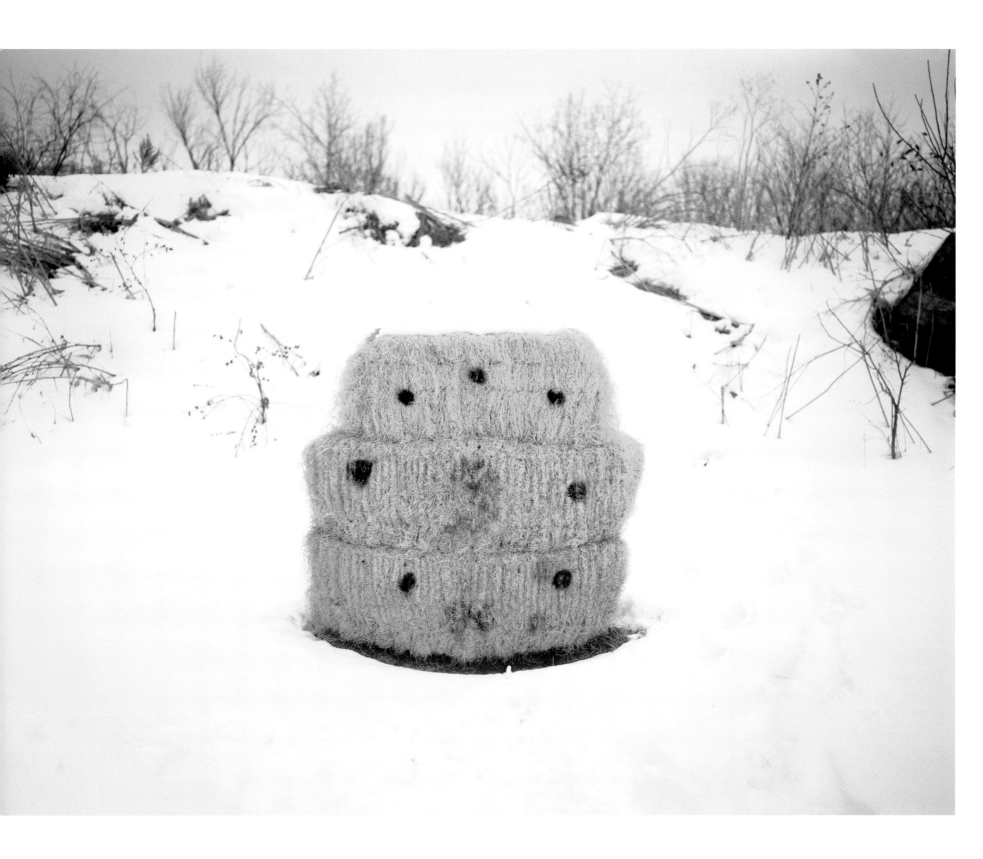

Girl Raking Leaves
GREENBELT, MARYLAND

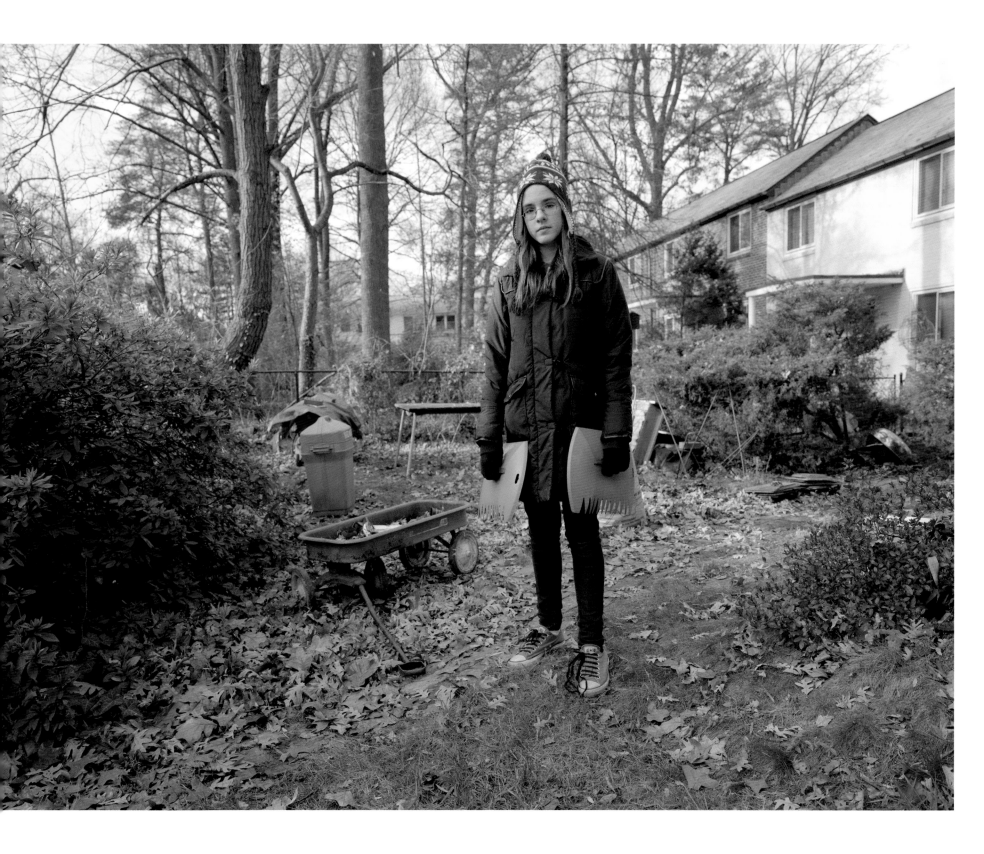

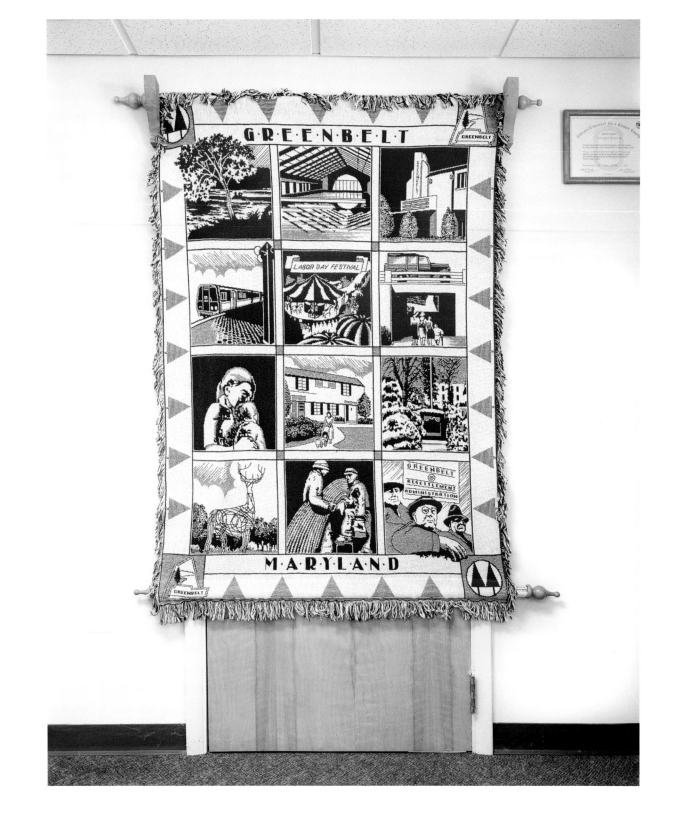

Quilt
GREENBELT, MARYLAND

" **Although I have seen the blueprints of Greenbelt, the actual sight itself exceeds anything I have dreamed of. I wish everyone in the country could see it.** "

———————————

Franklin D. Roosevelt,
on visiting Greenbelt in 1936

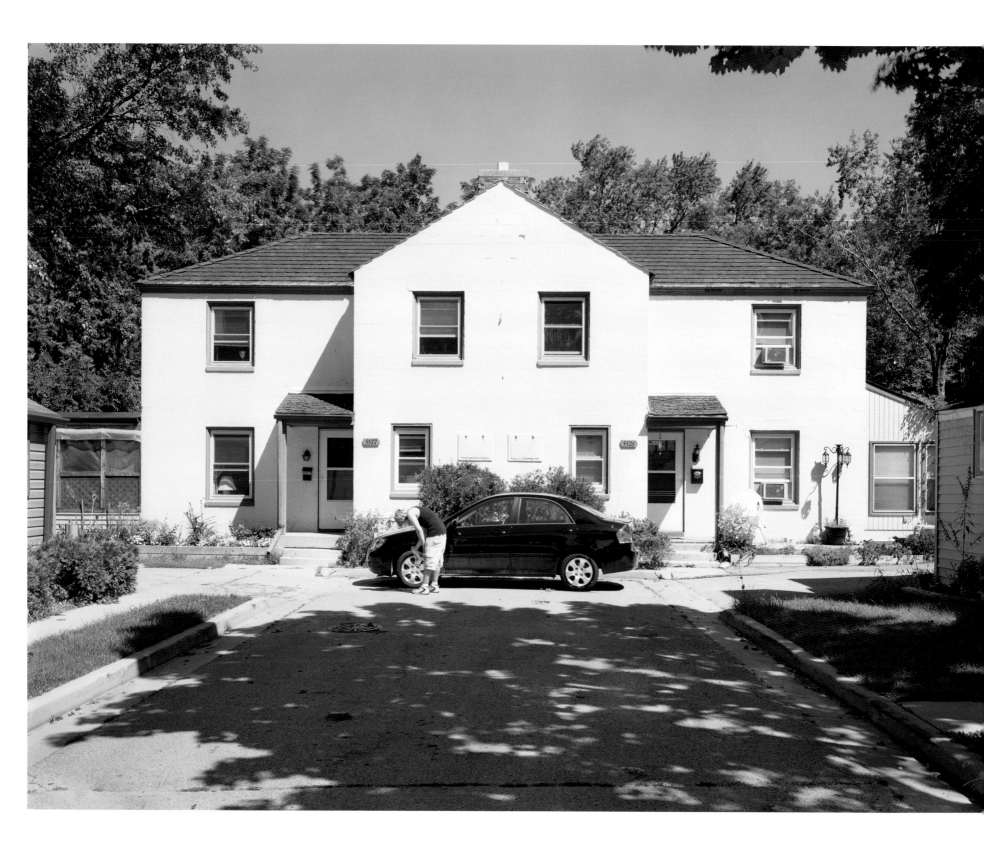

Boy Washing Car
GREENDALE, WISCONSIN

Gym Seats
GREENHILLS, OHIO

Winter Houses
GREENBELT, MARYLAND >

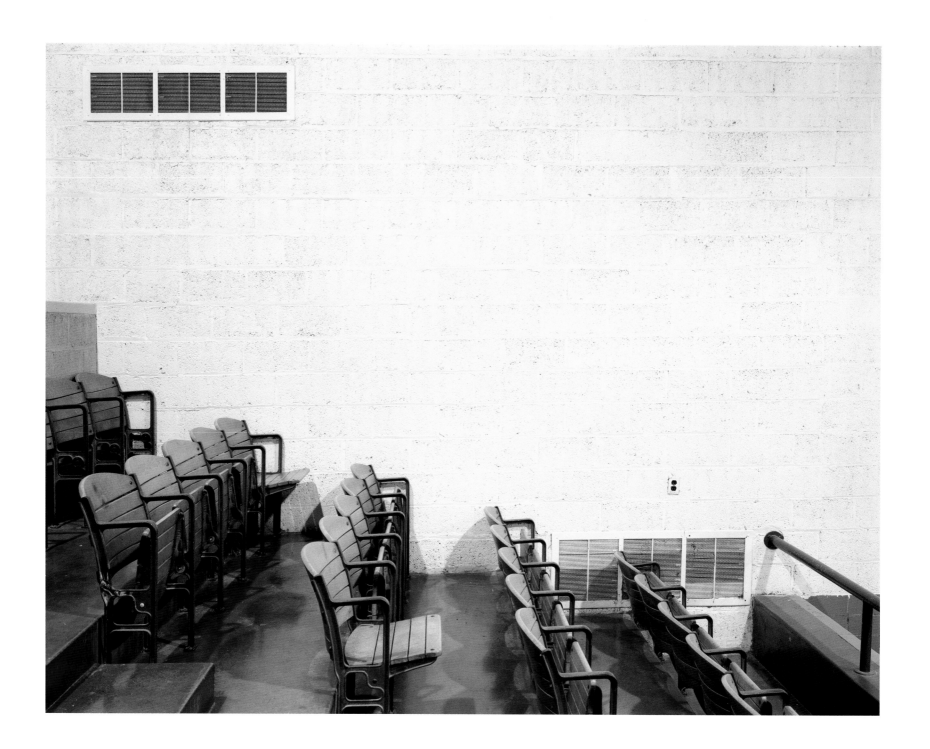

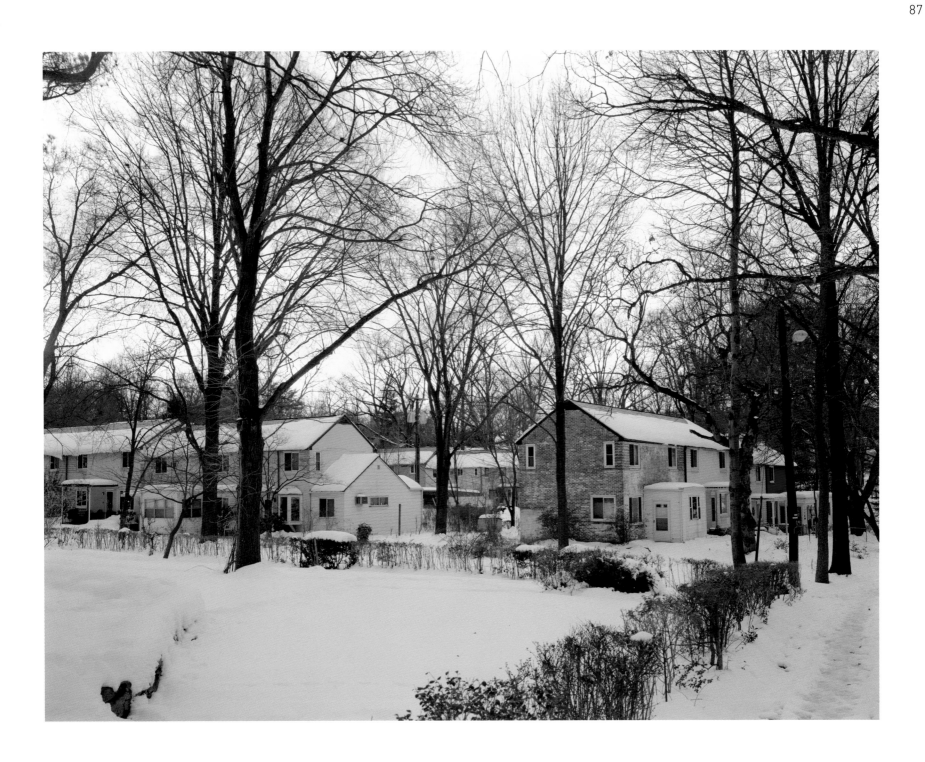

Music Room
GREENHILLS, OHIO

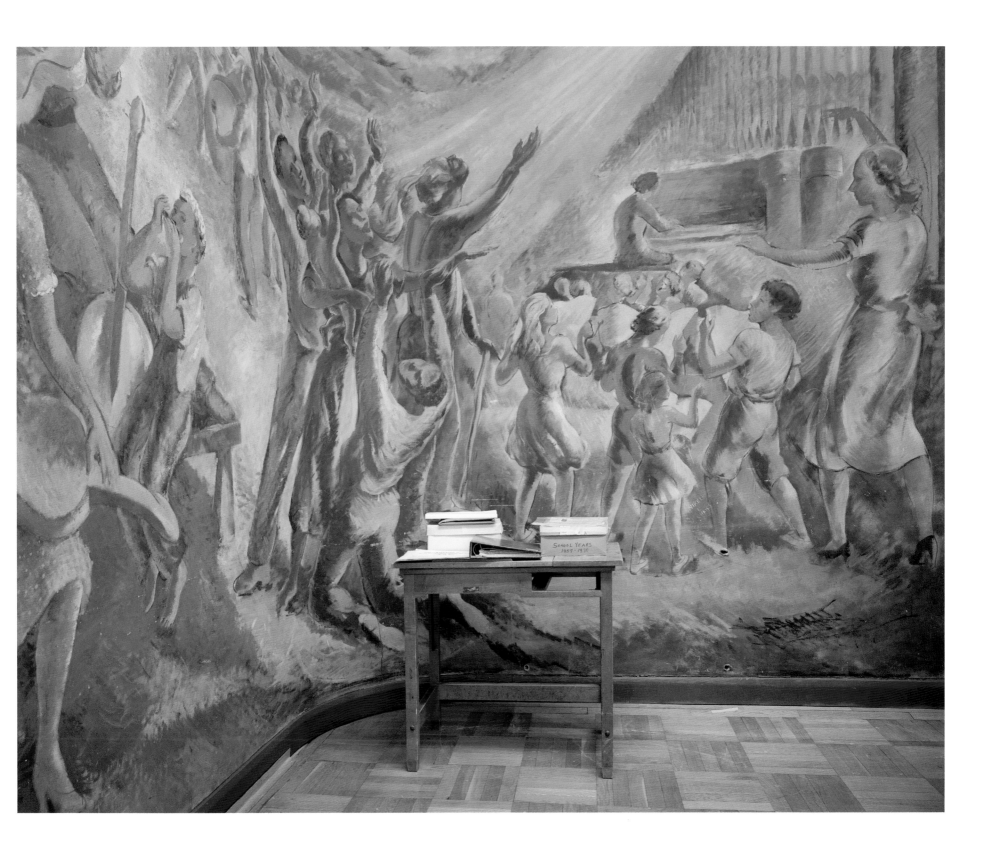

House Tour
GREENDALE, WISCONSIN

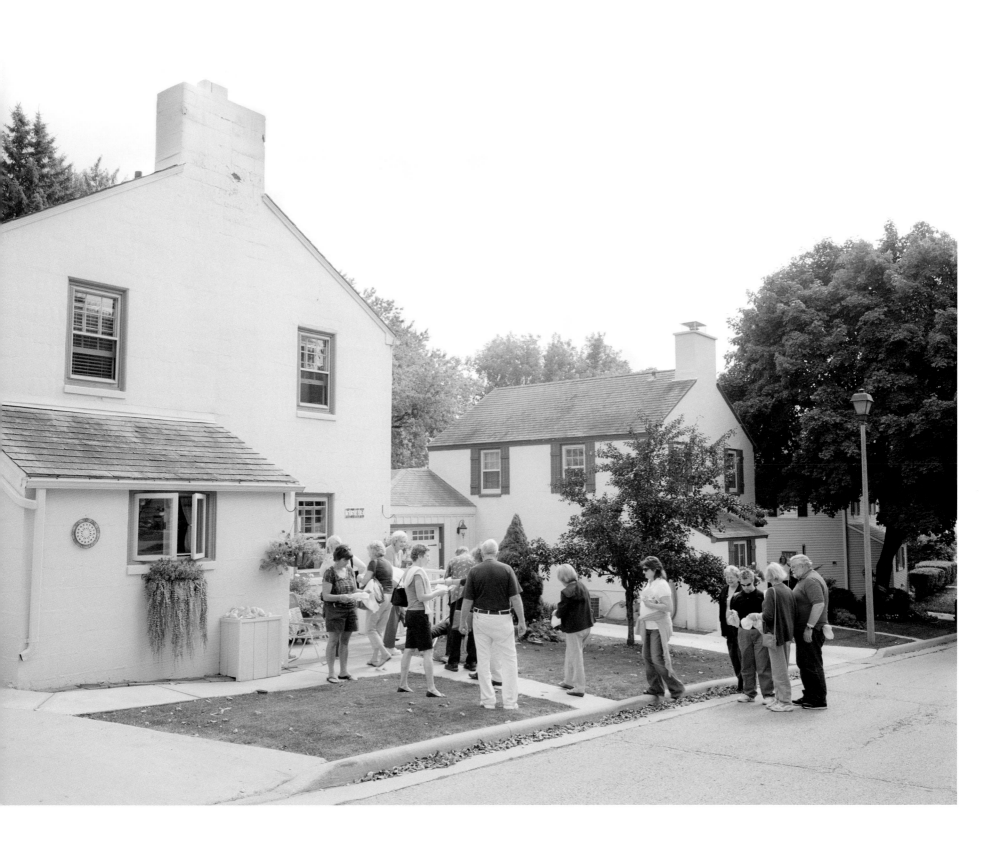

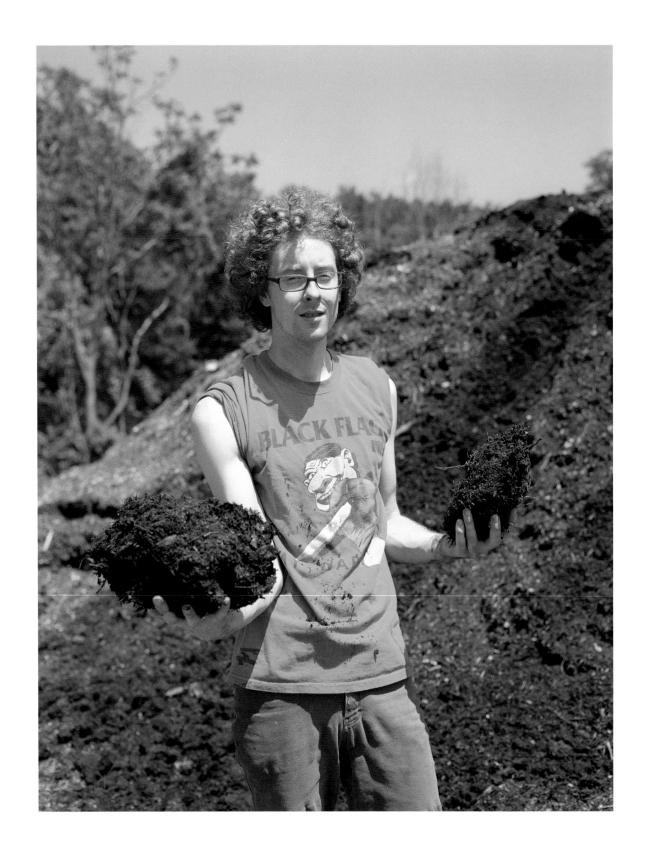

Teen with Compost
GREENBELT, MARYLAND

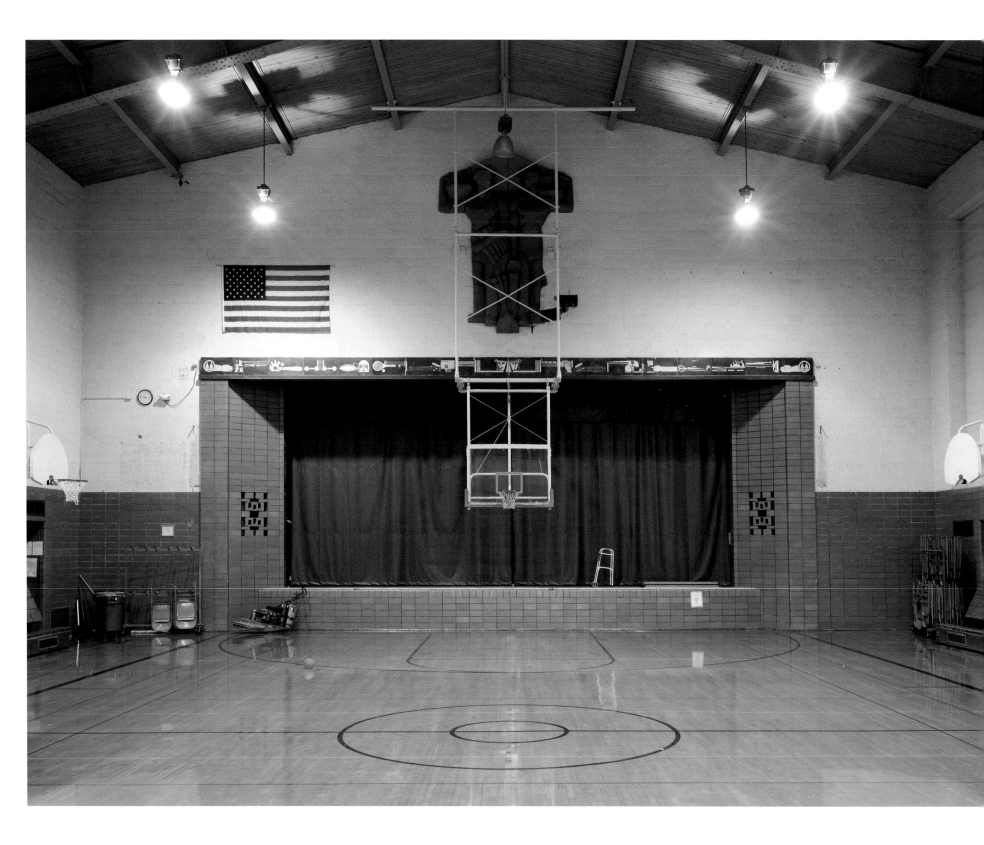

95


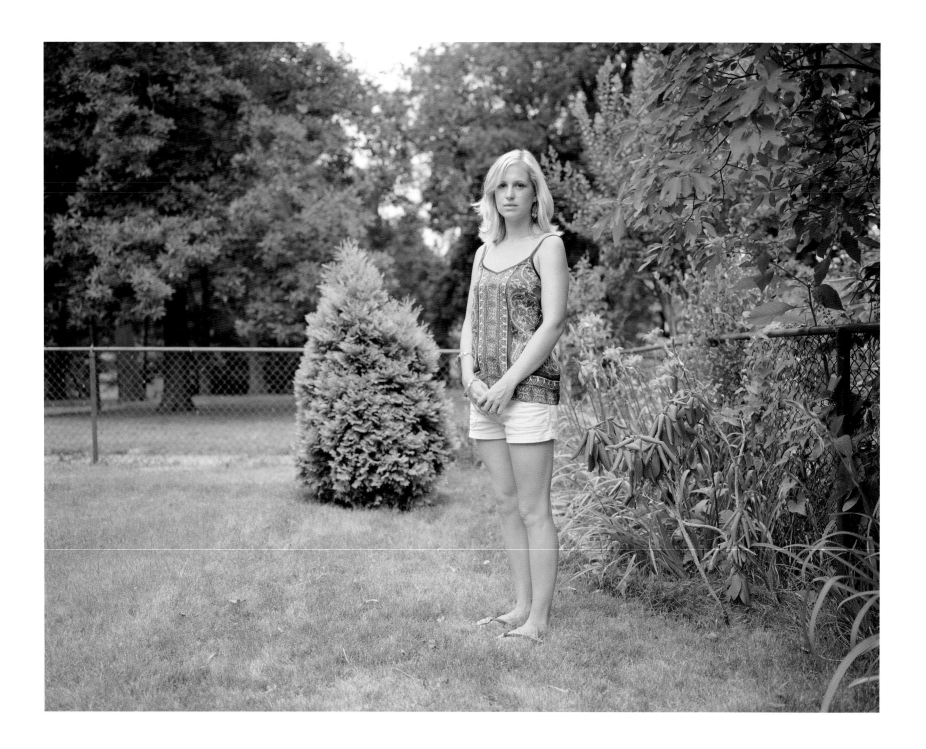

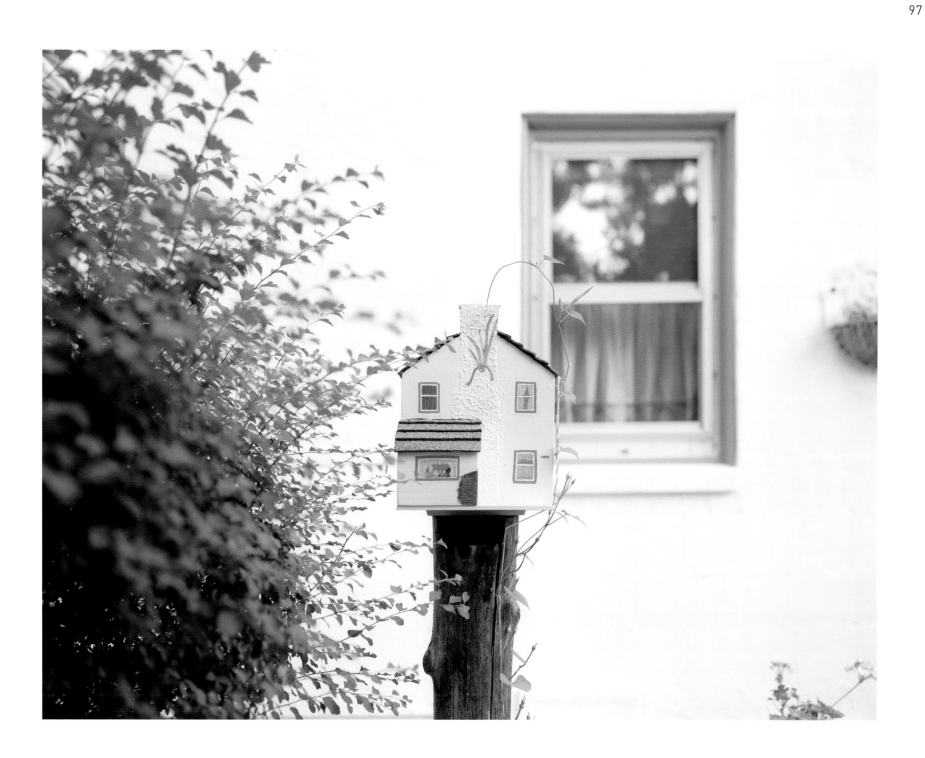

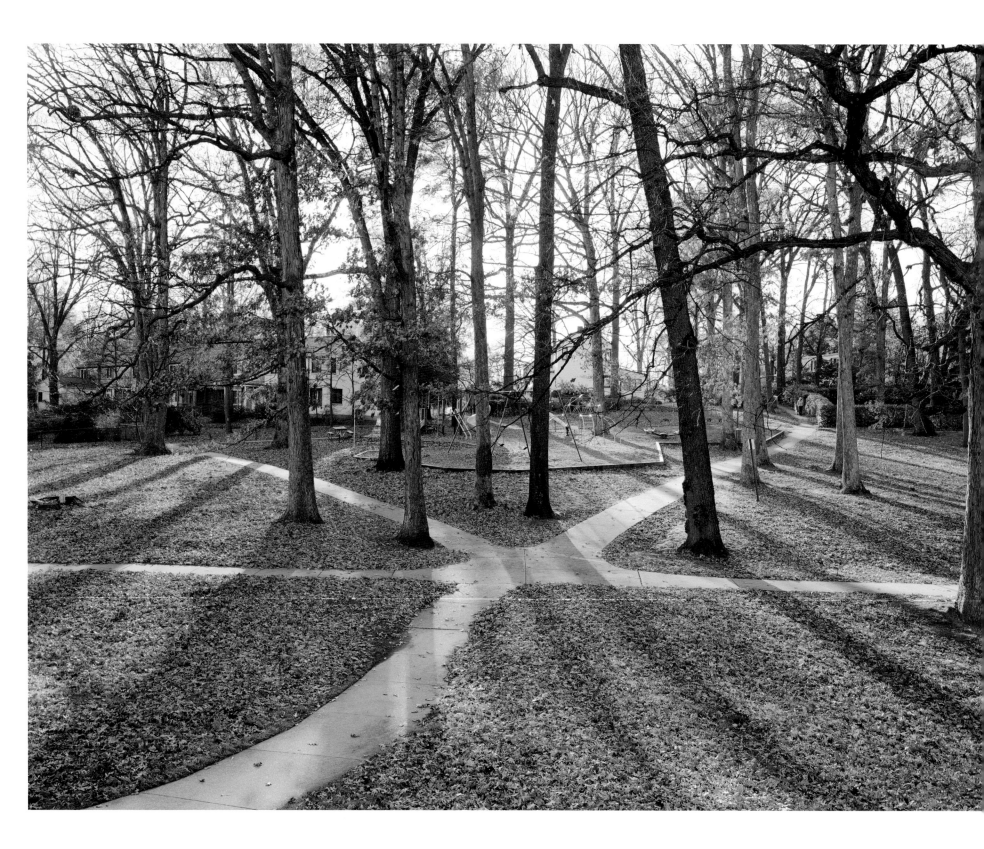

Converging Paths
GREENBELT, MARYLAND

Rockwell Covers
GREENDALE, WISCONSIN

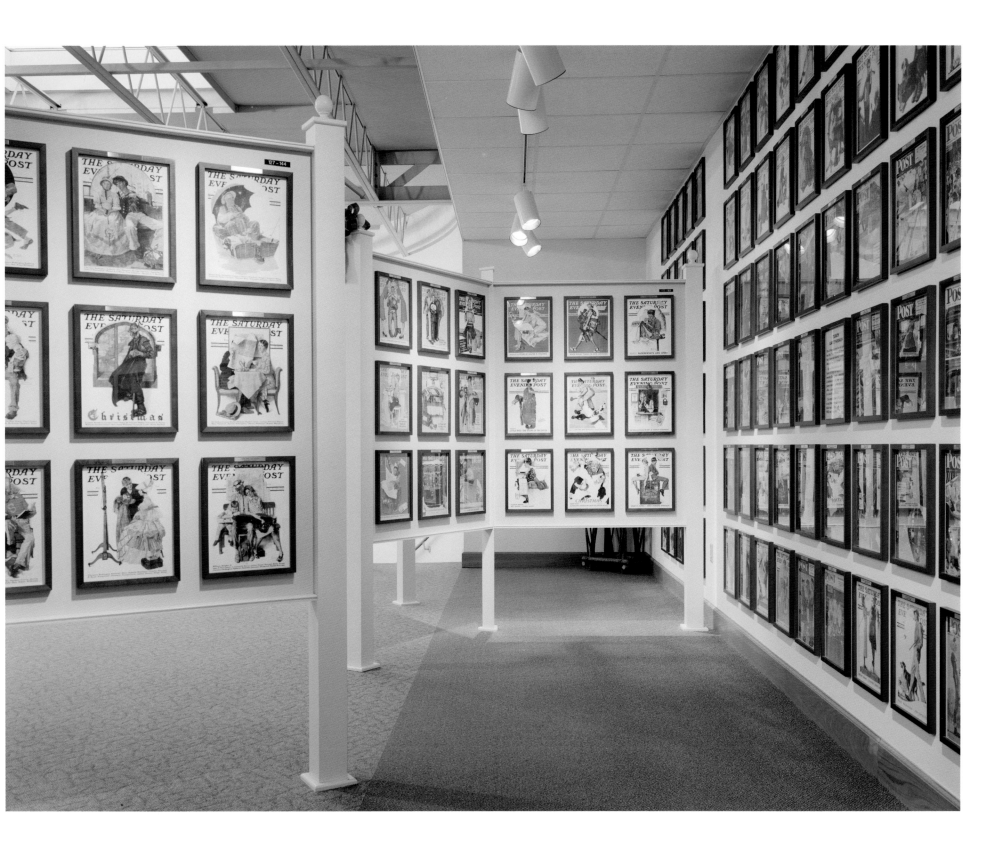

Wall Grid
GREENHILLS, OHIO

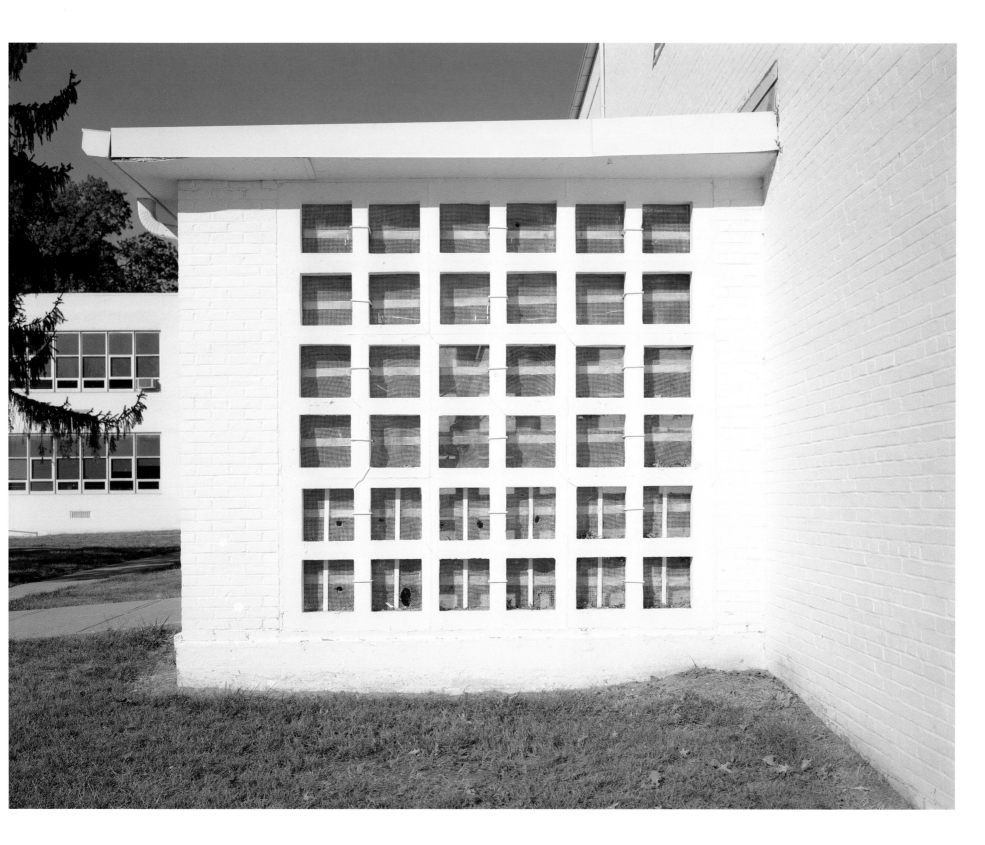

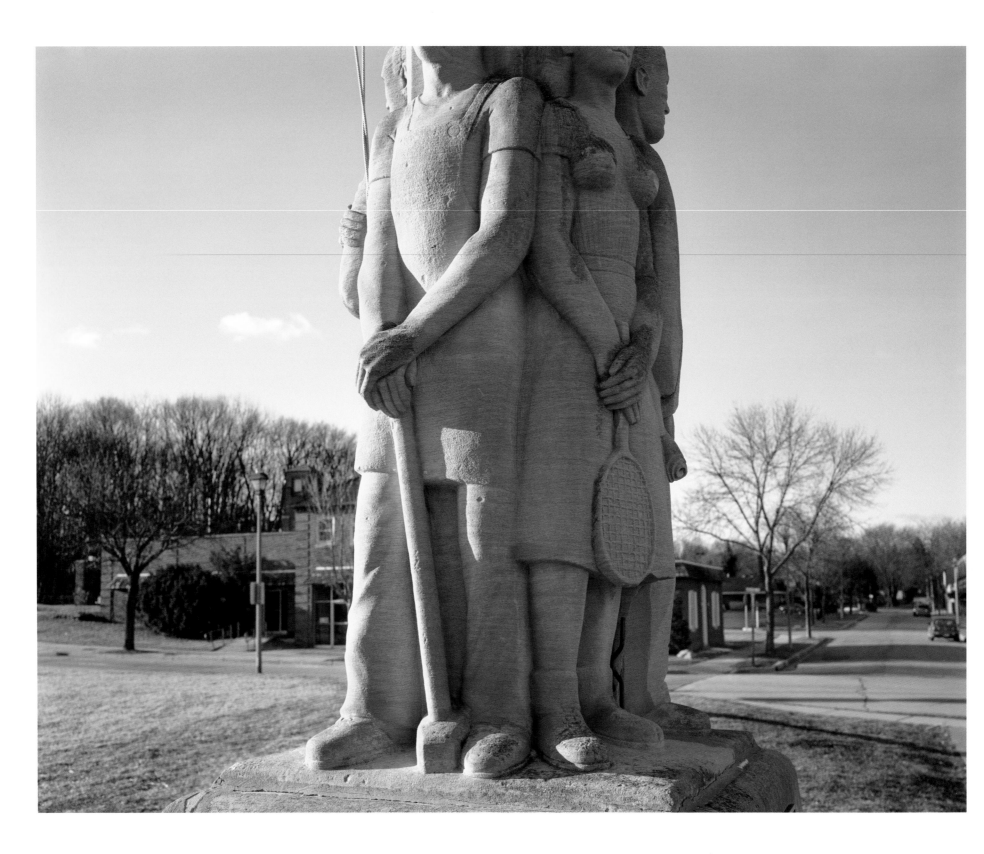

Hauser Sculpture
GREENDALE, WISCONSIN

Park Hazard
GREENHILLS, OHIO

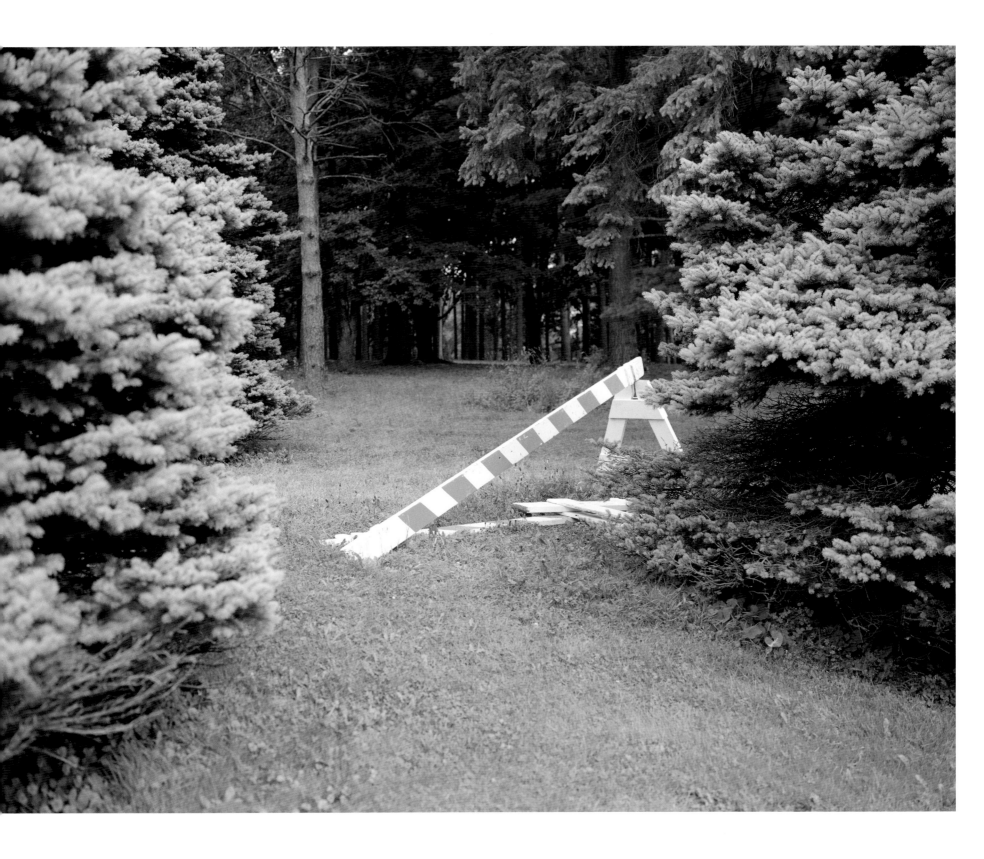

Compost
GREENBELT, MARYLAND

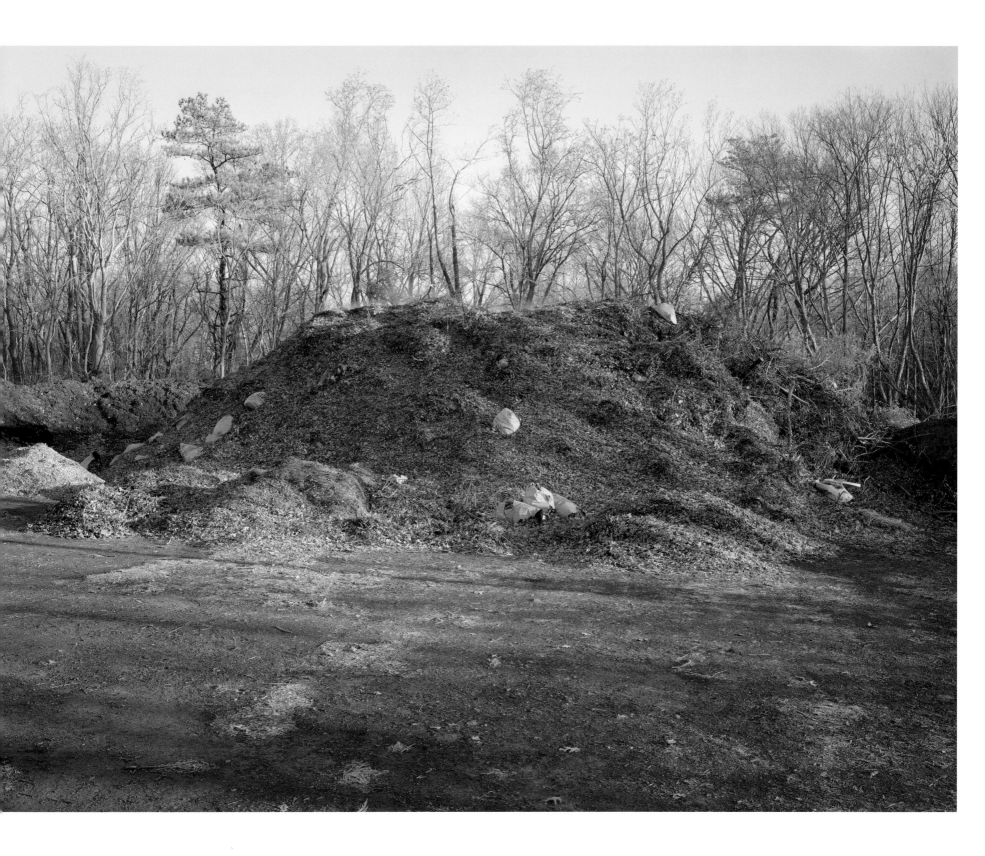

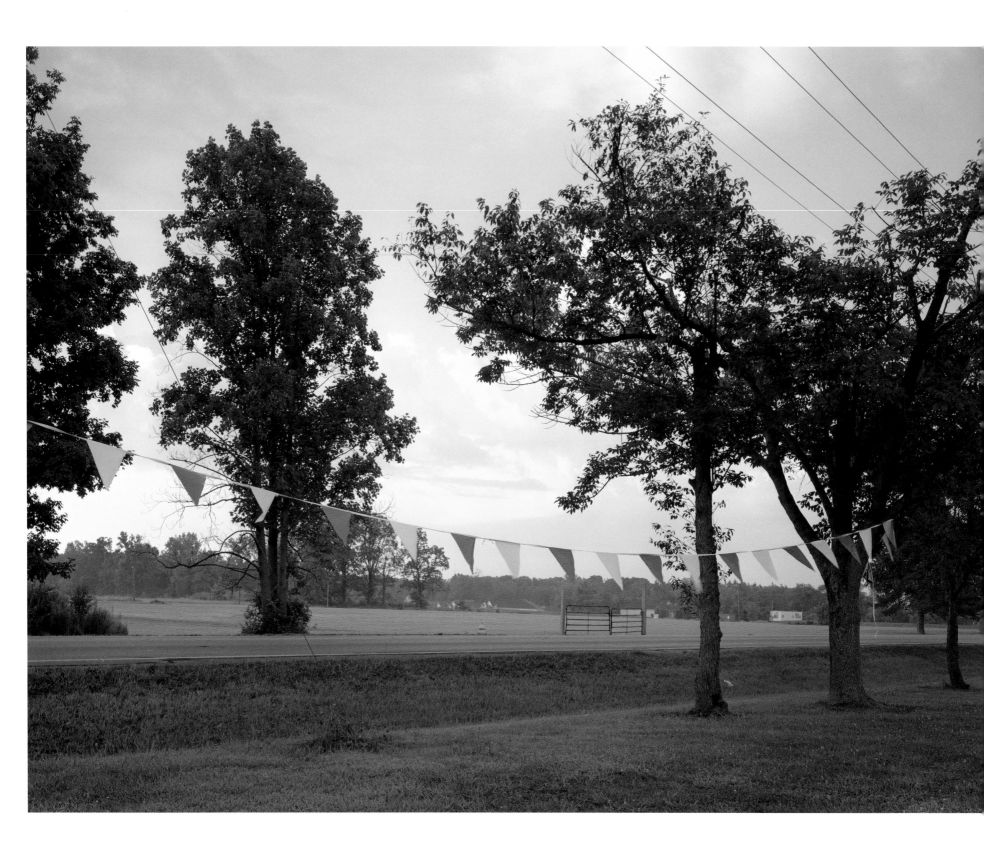

Pennant Flags
GREENHILLS, OHIO

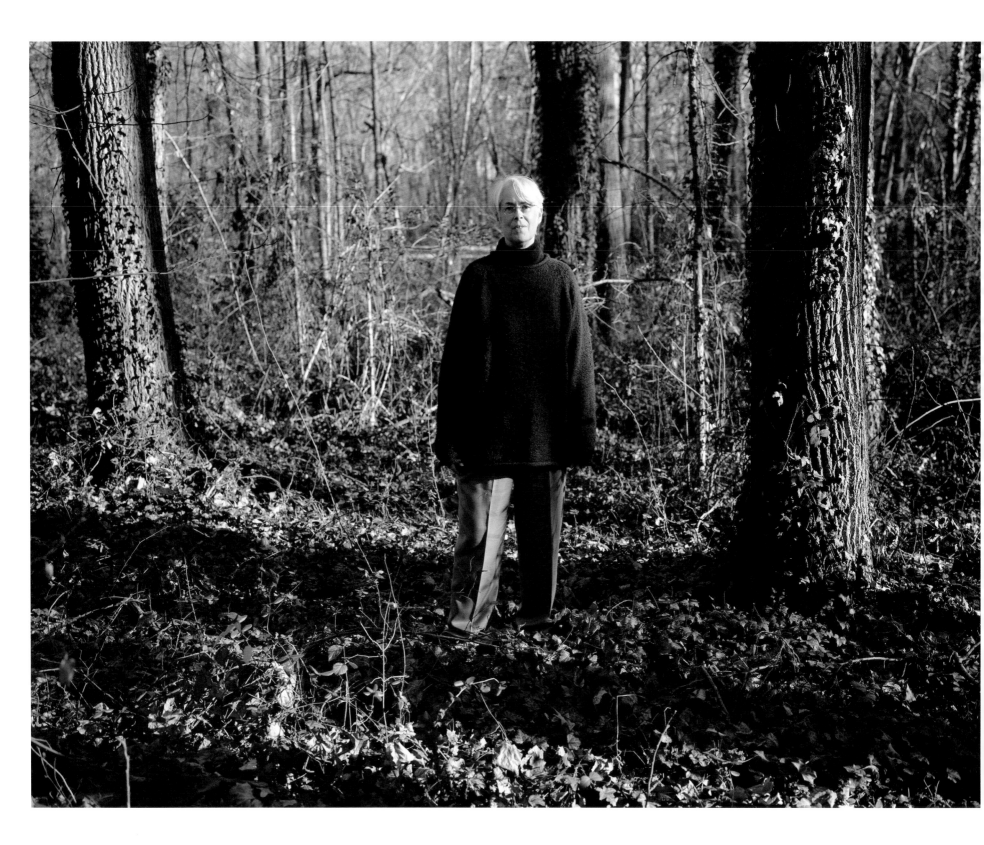

Woman in Woods
GREENBELT, MARYLAND

Office Park
GREENBELT, MARYLAND
Park Stage
GREENBELT, MARYLAND >

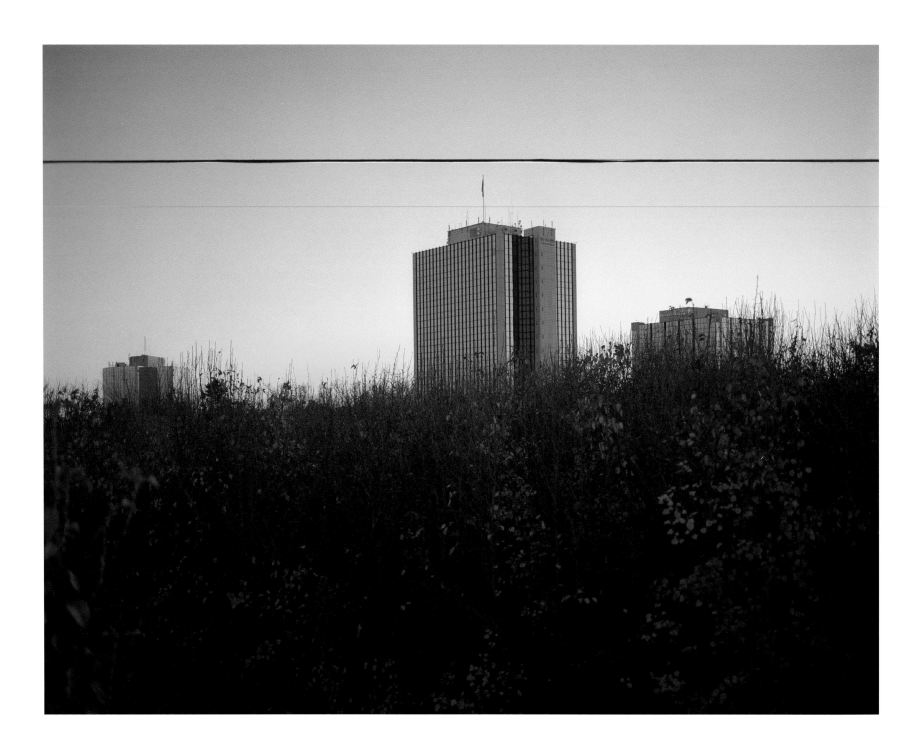

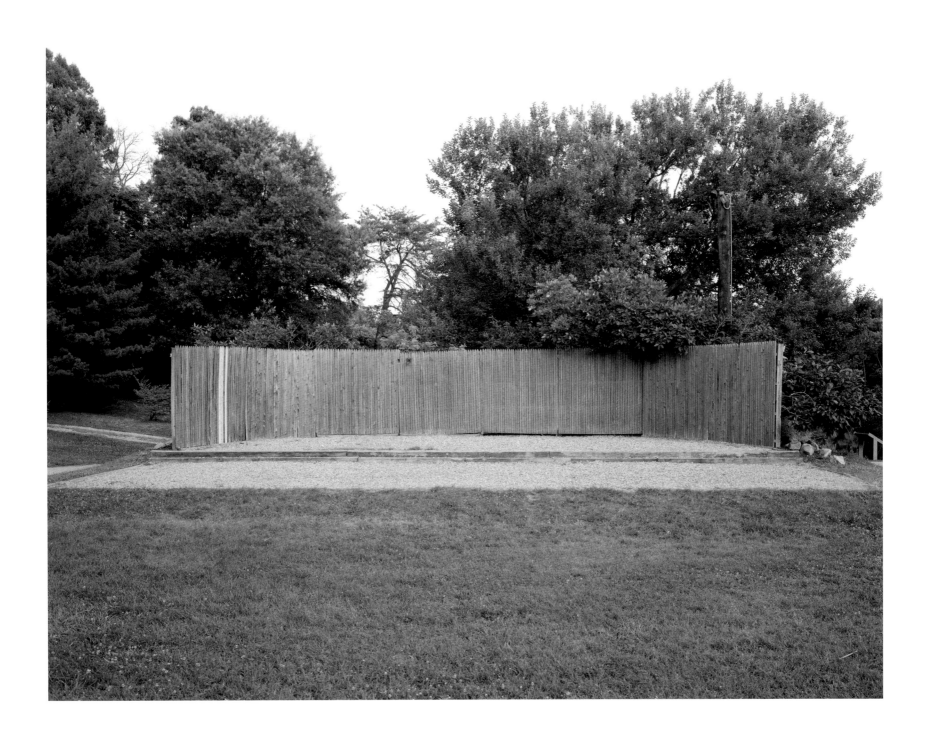

Brook
GREENDALE, WISCONSIN

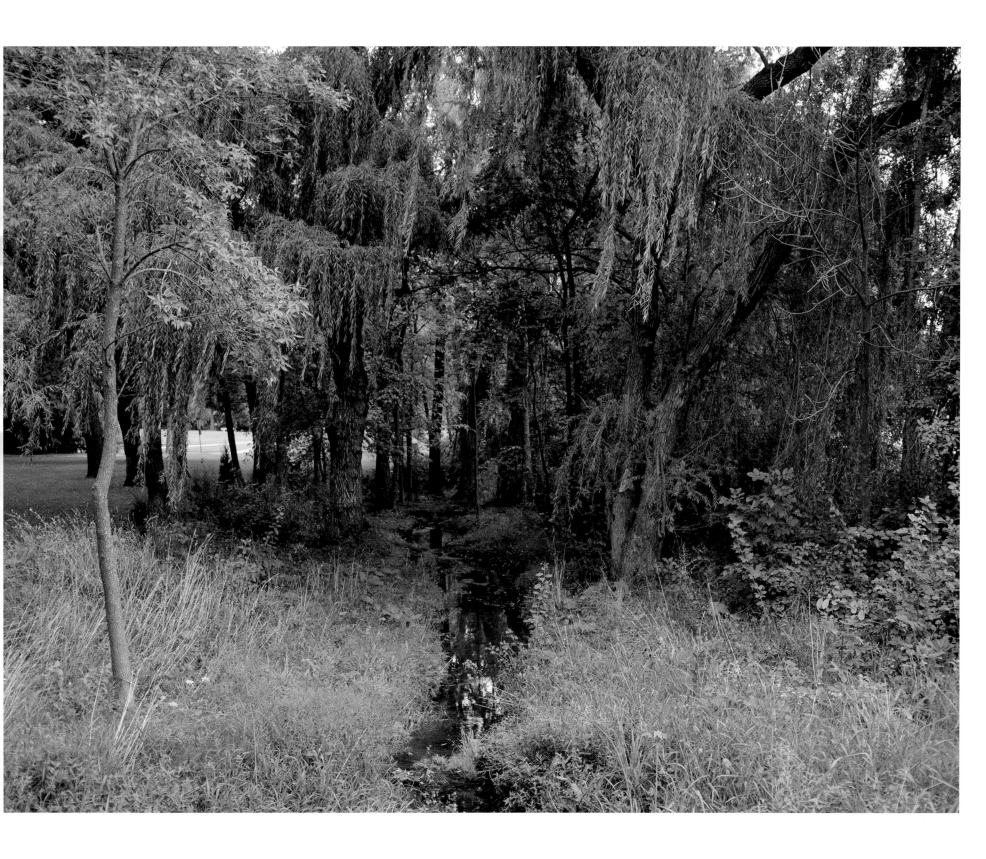

Village Hall Desk
GREENDALE, WISCONSIN

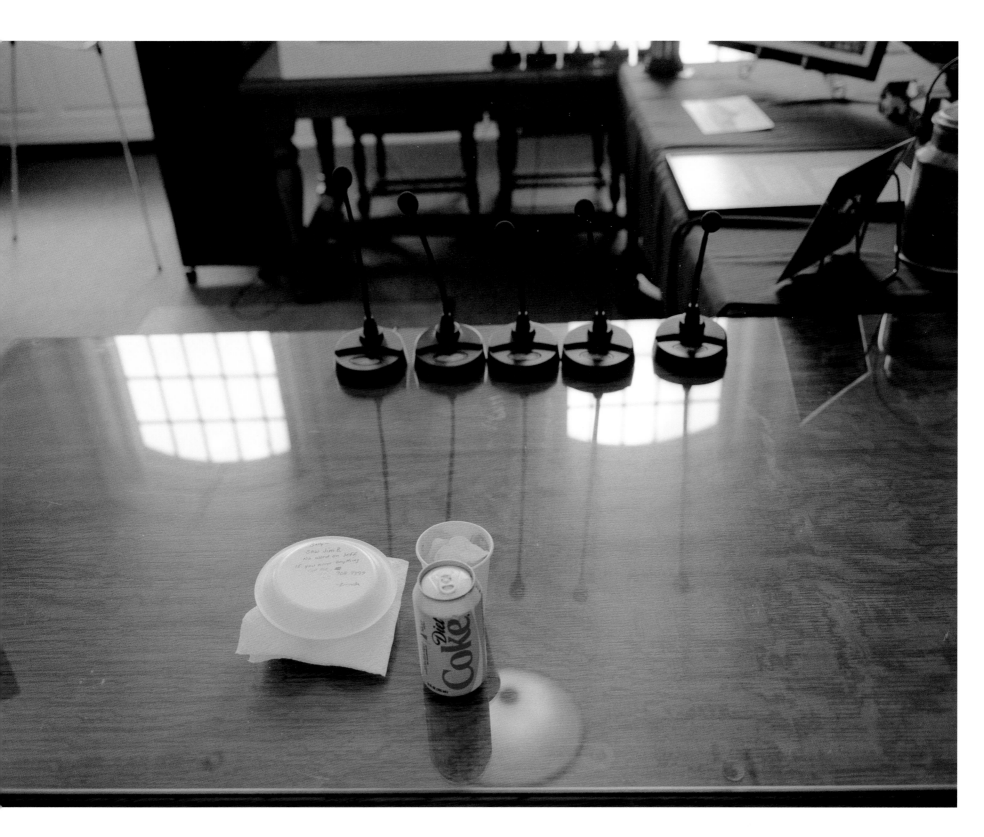

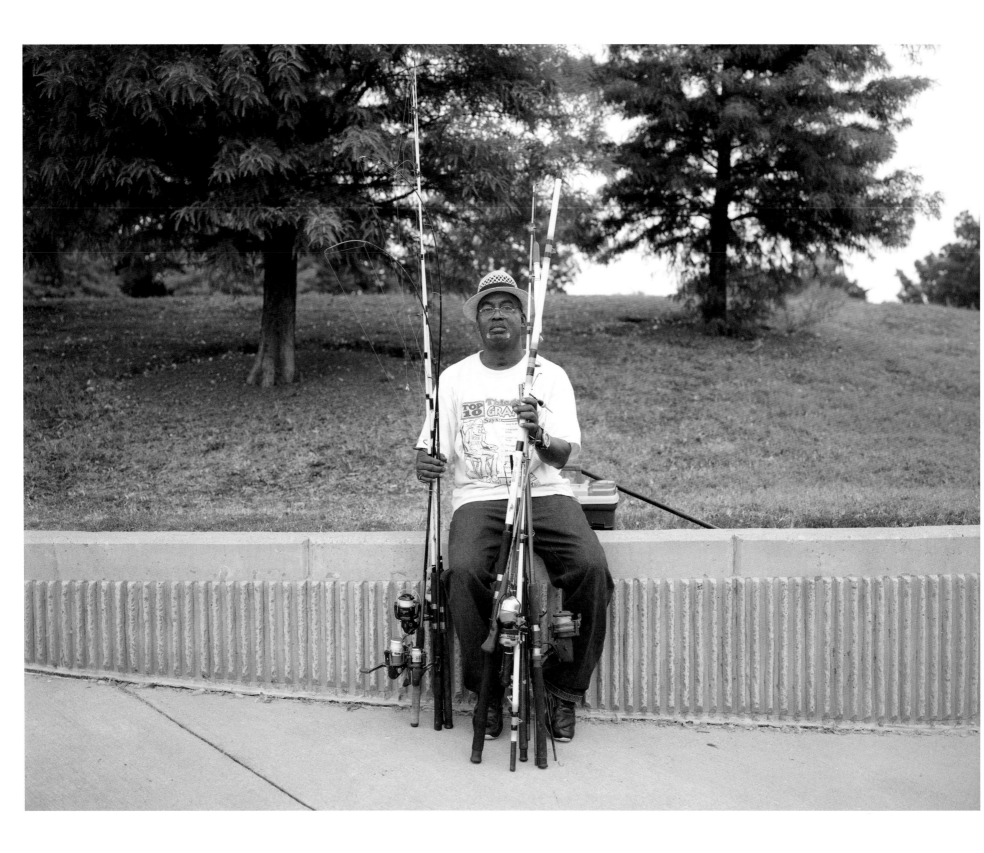

Man with Fishing Poles
GREENHILLS, OHIO

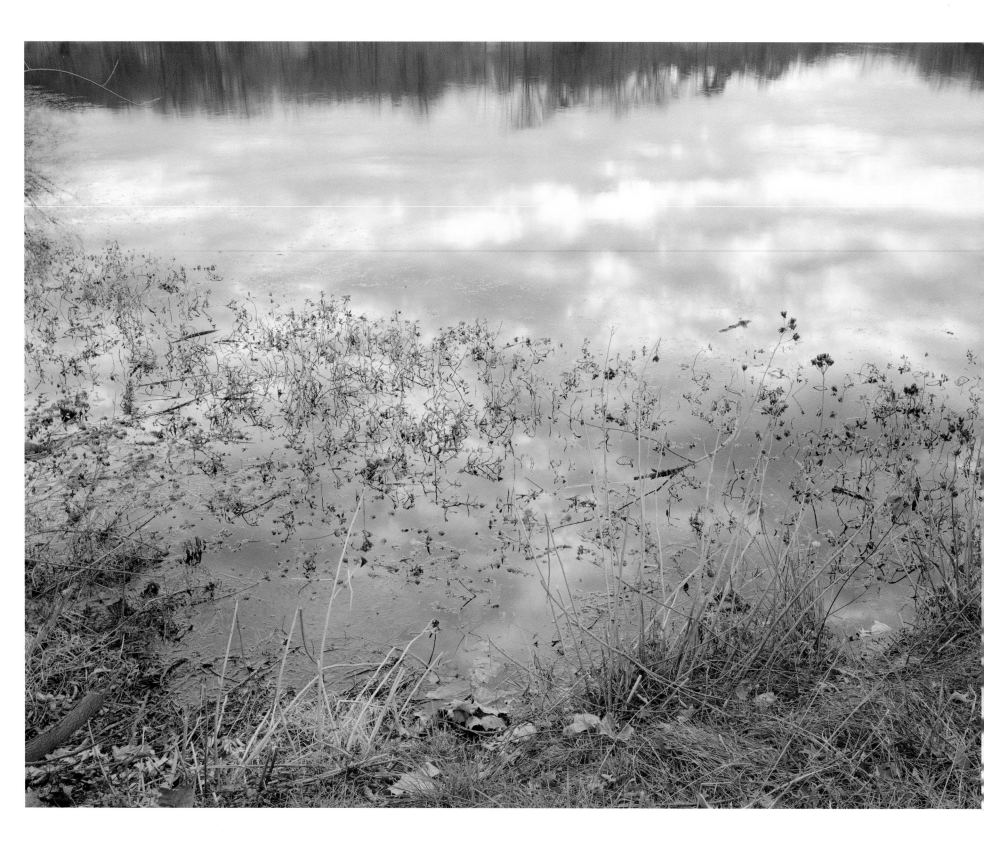

Greenbelt Lake
GREENBELT, MARYLAND

Parade
GREENDALE, WISCONSIN

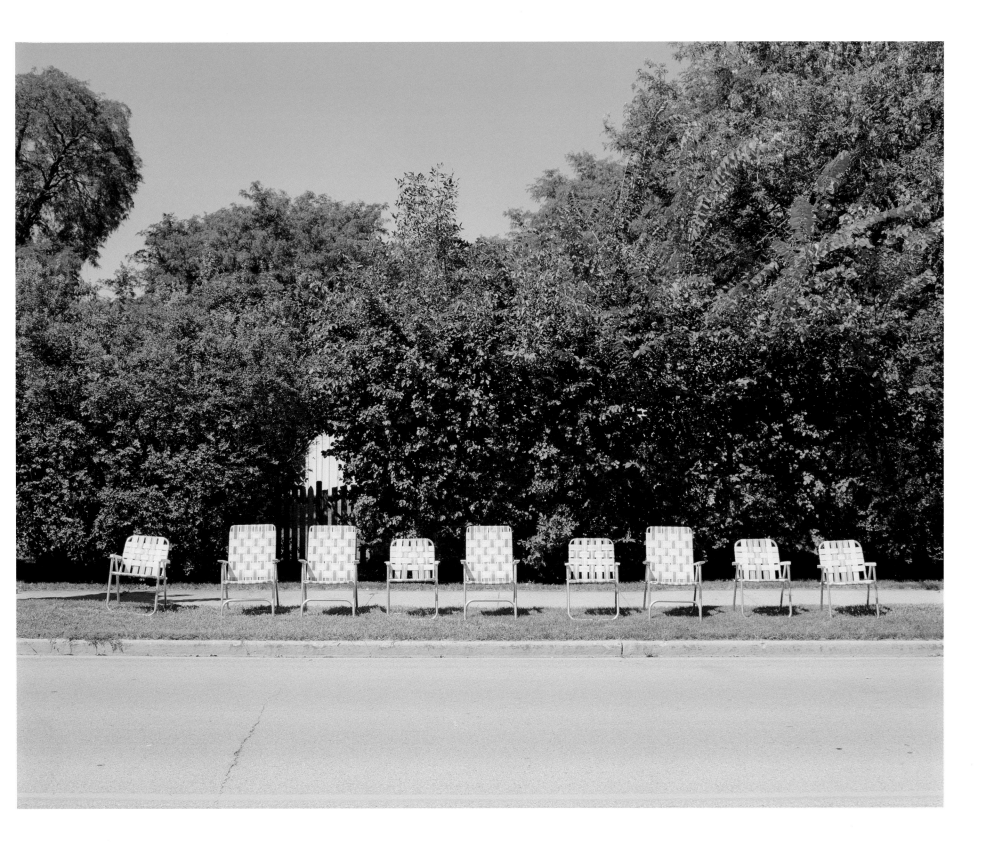

" Let us enlighten, then, our earthly burdens
By going back to school, this time in gardens
That burn no hotter than the summer day.
By birth and growth, ripeness, death and decay,
By goods that bind us to all living things,
Life of our life, the garden lives and sings. "

Wendell Berry,
"A Speech to the Garden
Club of America," 2009

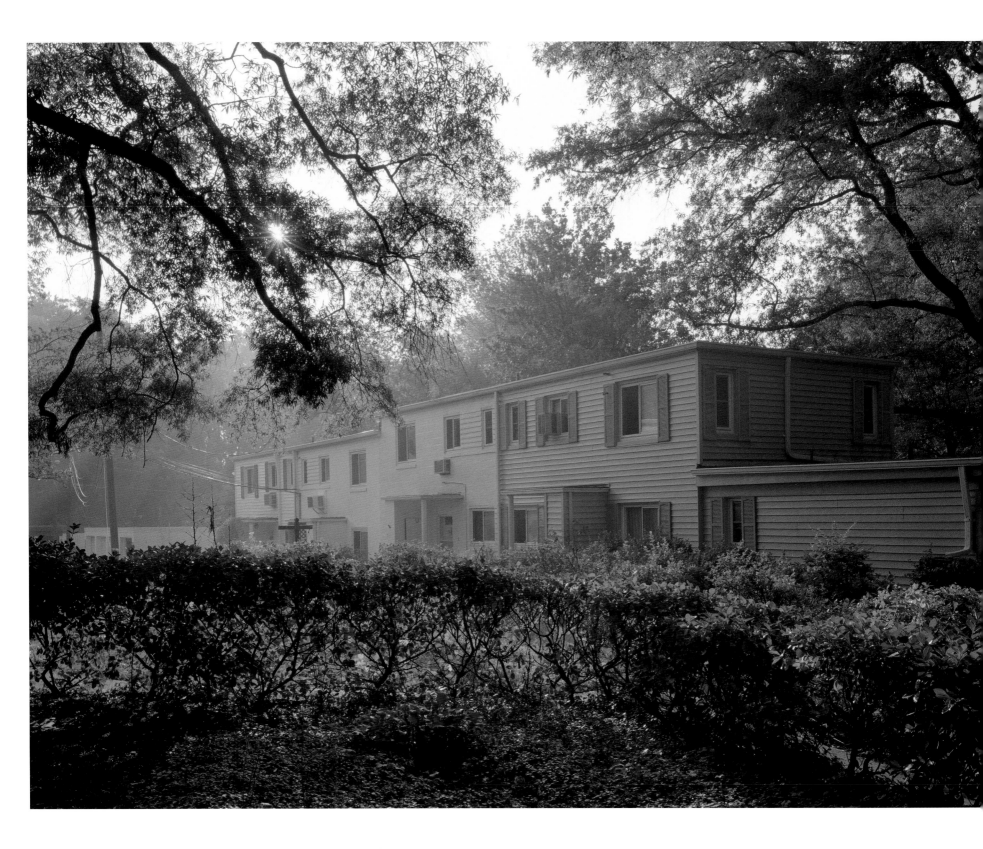

Morning Fog
GREENBELT, MARYLAND

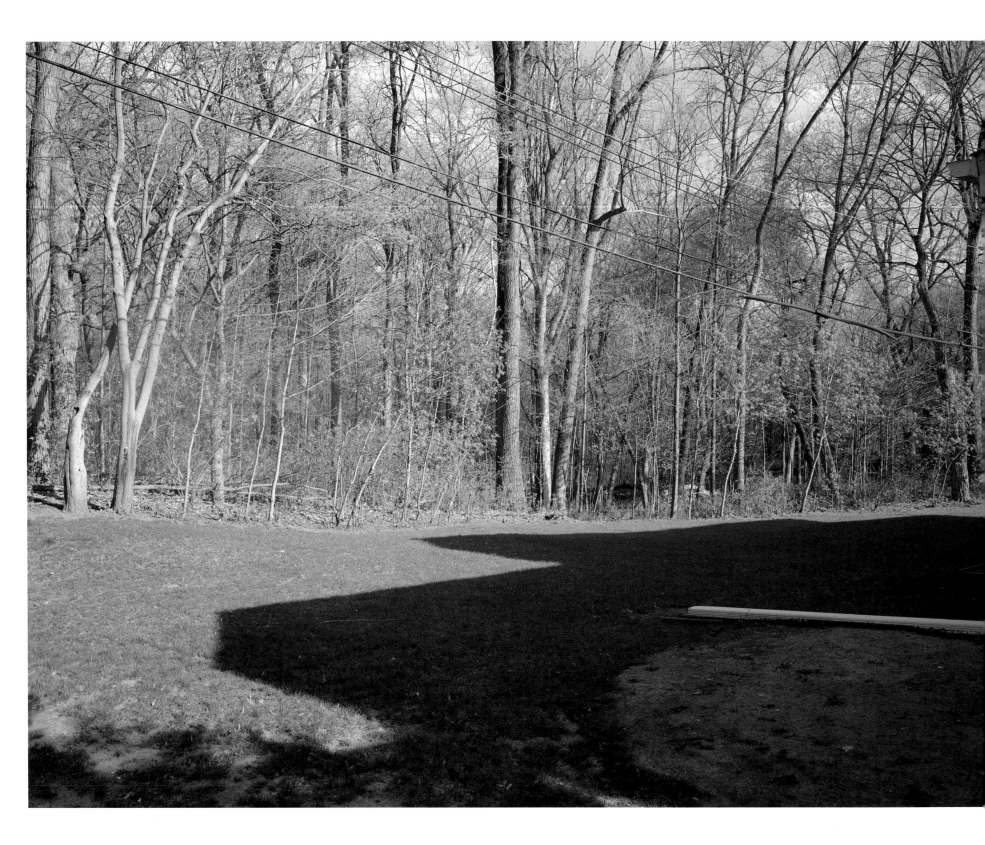

Gutter and Shadow
GREENDALE, WISCONSIN

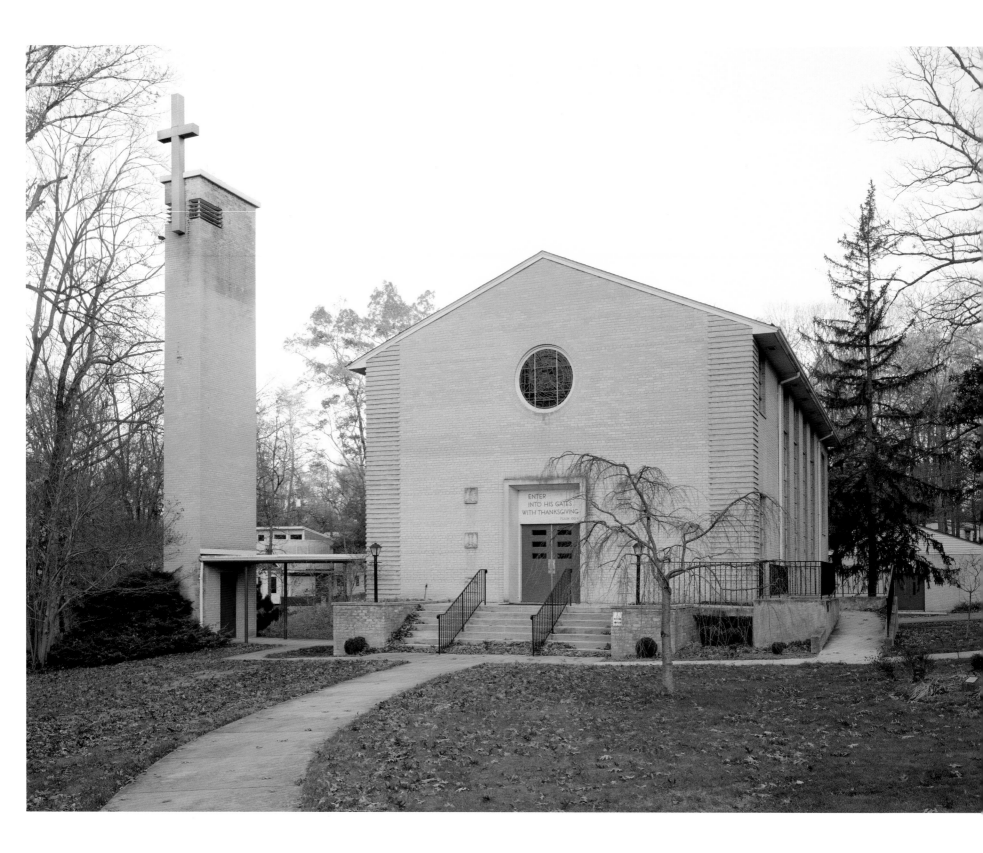

Church
GREENBELT, MARYLAND

Stone Animals
GREENHILLS, OHIO

Clinging Vine
GREENHILLS, OHIO >

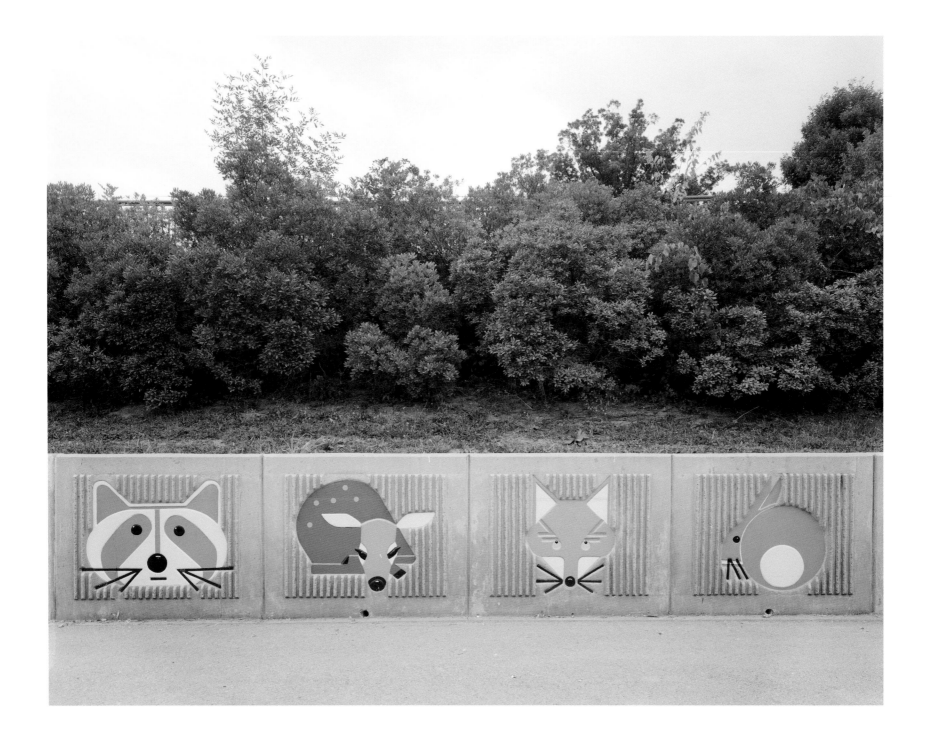

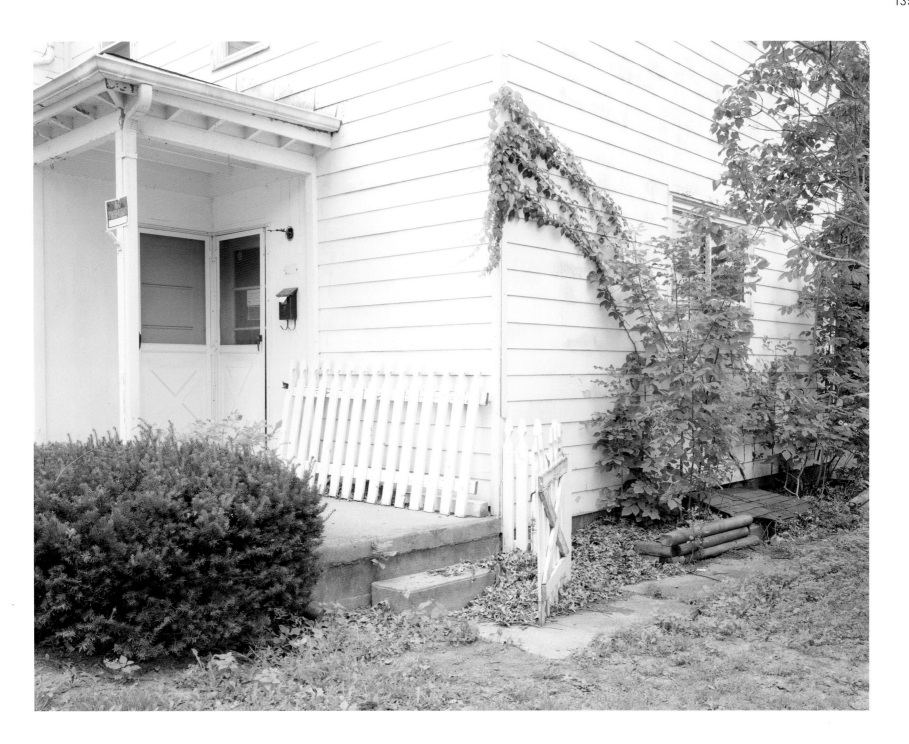

Swing and Shrubs
GREENBELT, MARYLAND

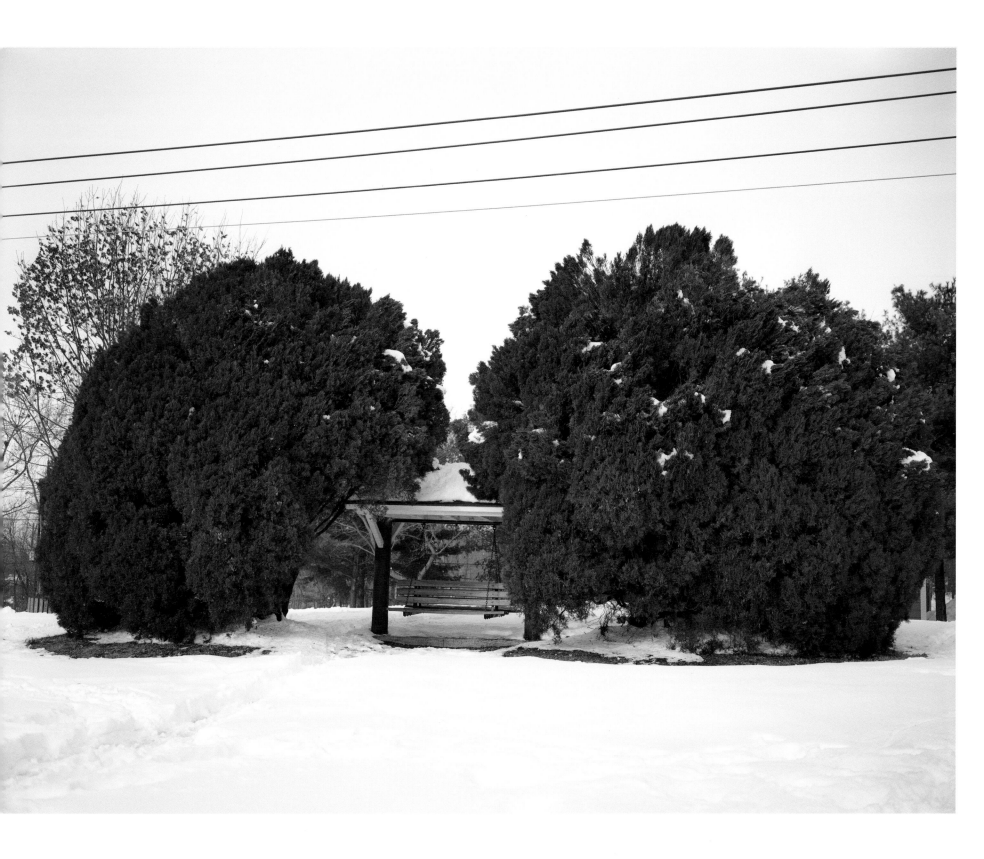

Water Tower
GREENDALE, WISCONSIN

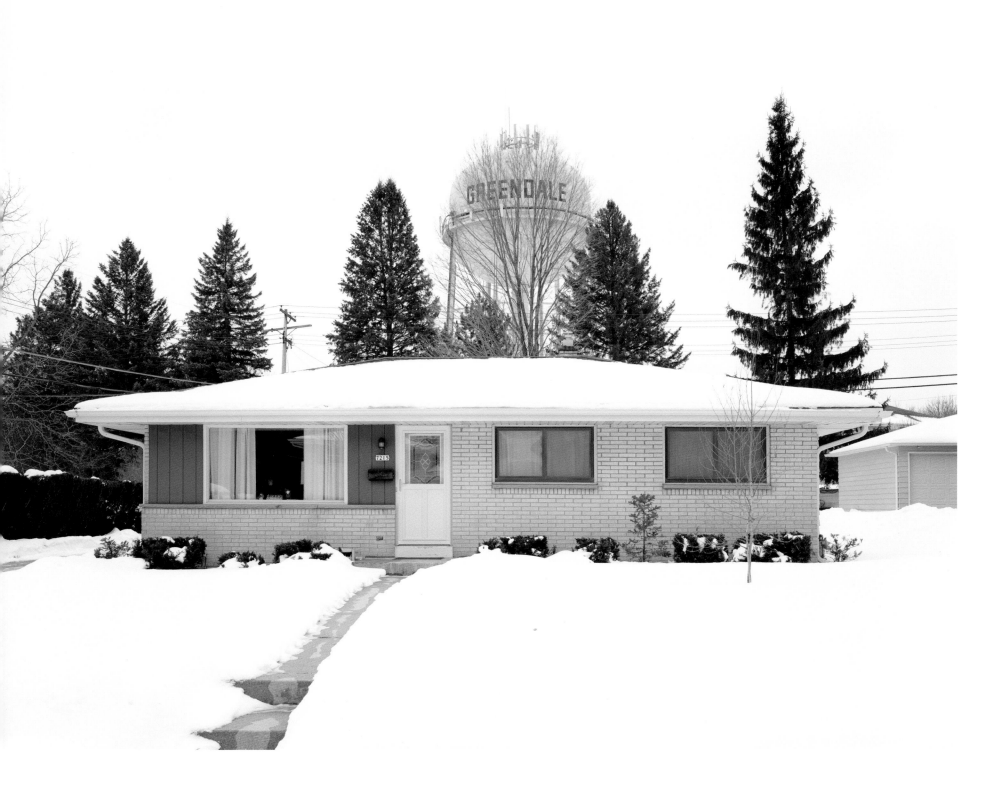

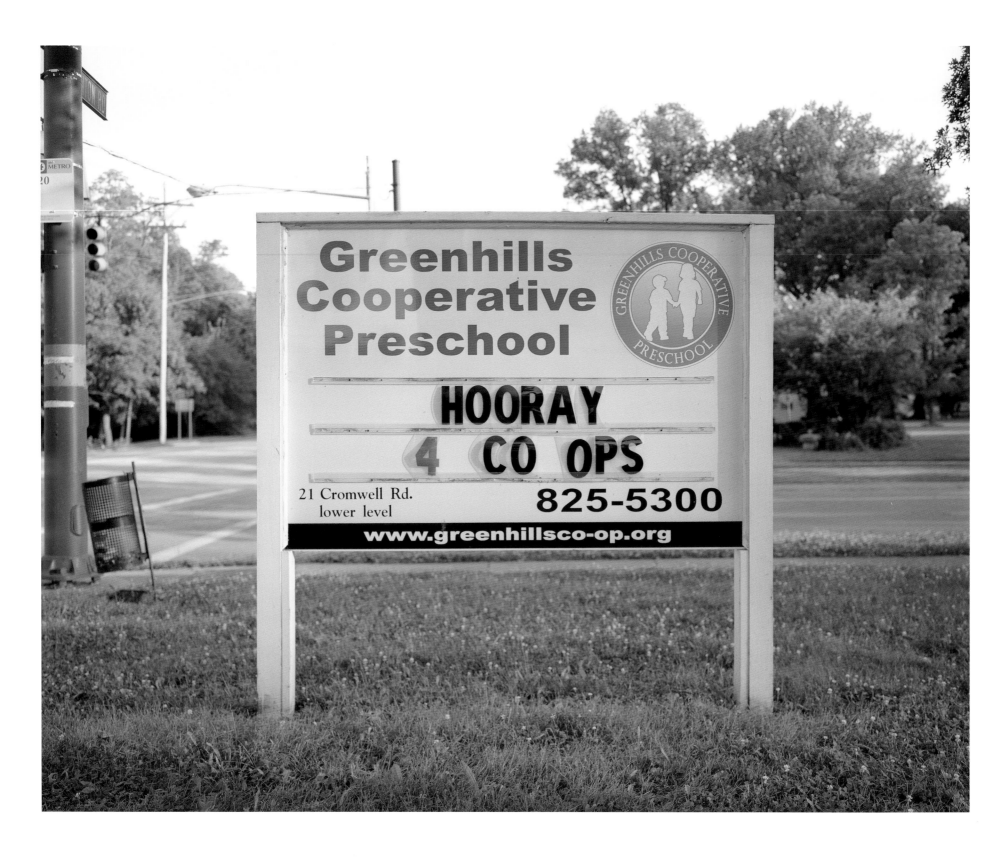

Hooray 4 Co-Ops
GREENHILLS, OHIO

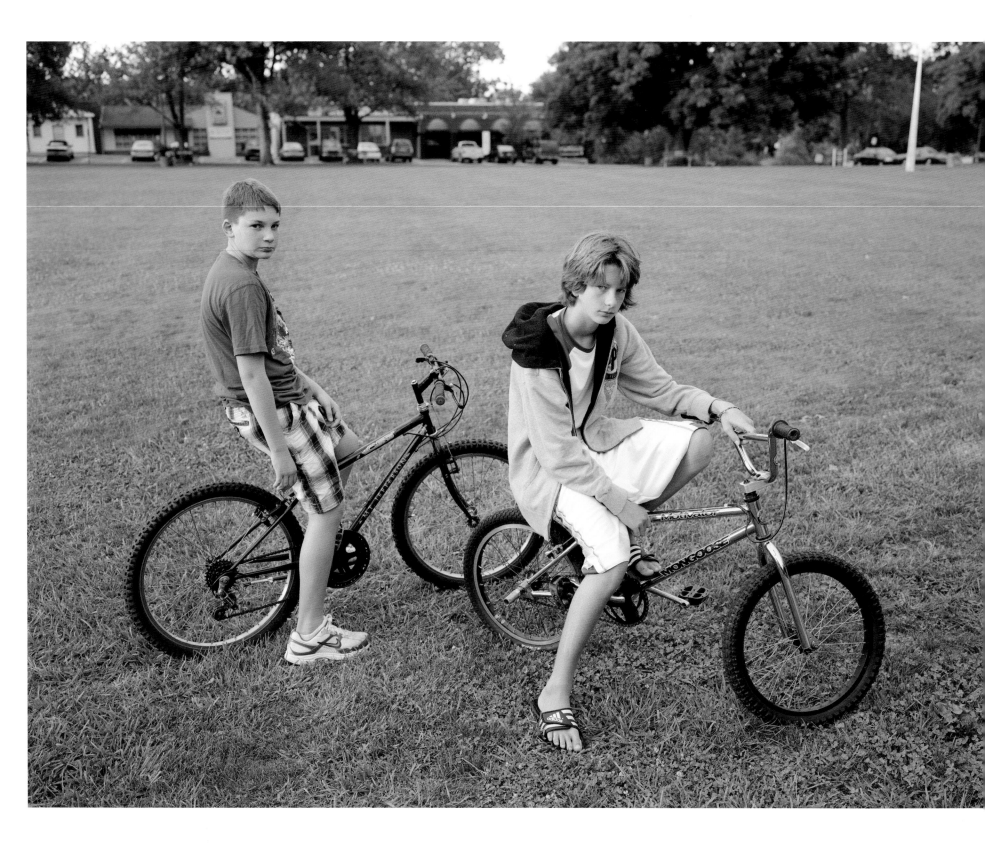

143

Boys on Bikes
GREENHILLS, OHIO

Greenbelt Theatre
GREENBELT, MARYLAND
Disney Garages
GREENDALE, WISCONSIN >

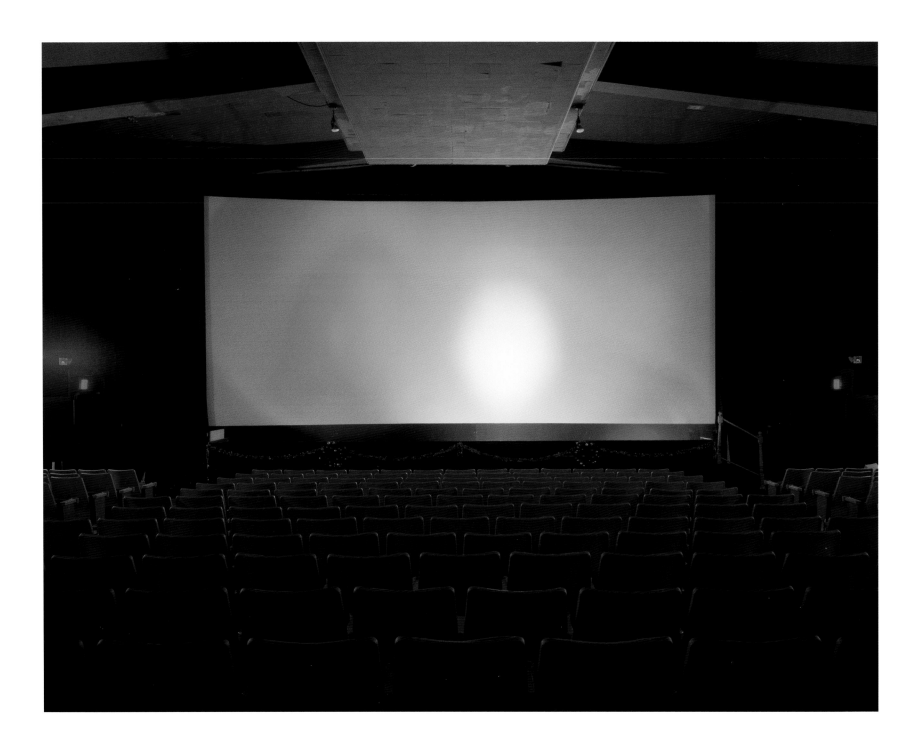

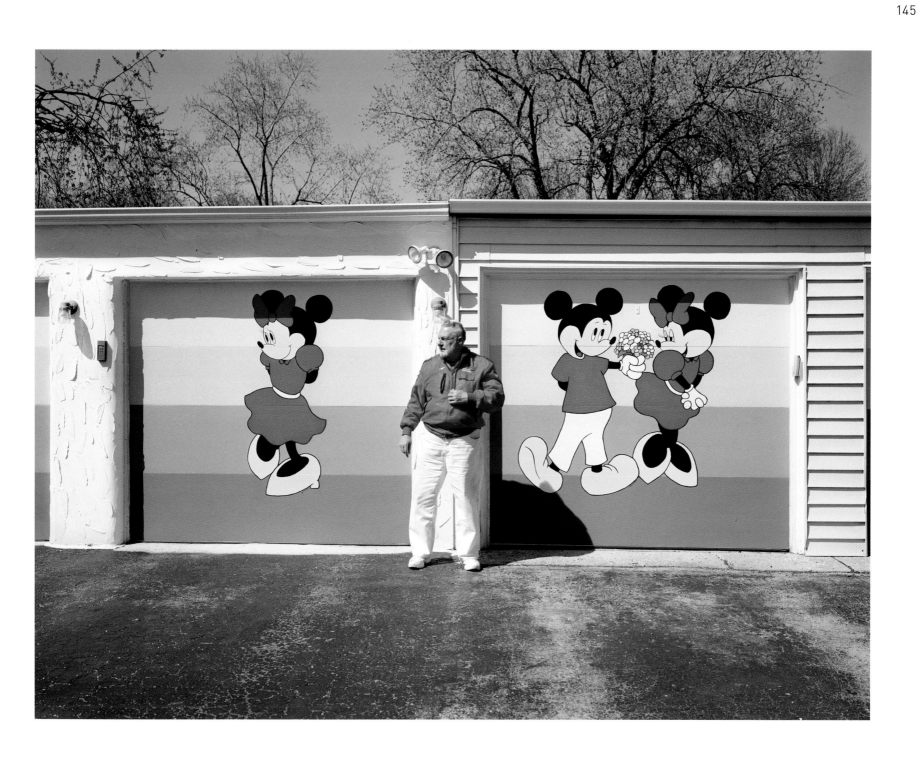

Forest Path

GREENDALE, WISCONSIN

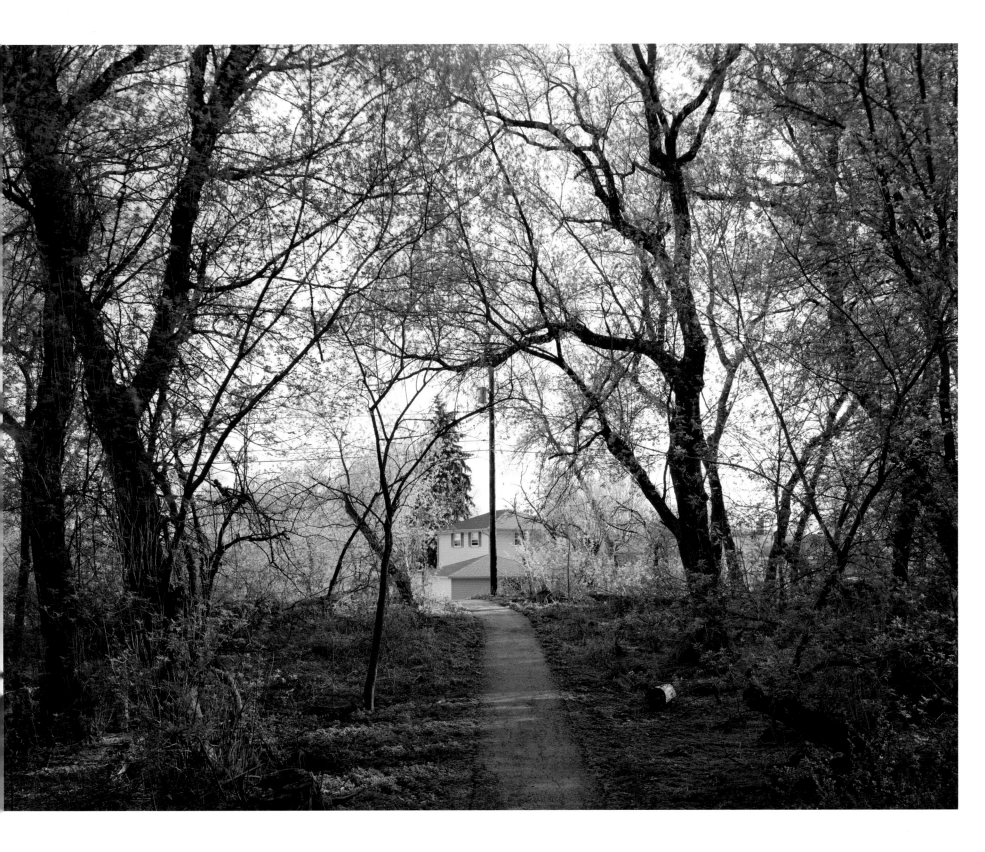

Tree and Highway
GREENBELT, MARYLAND

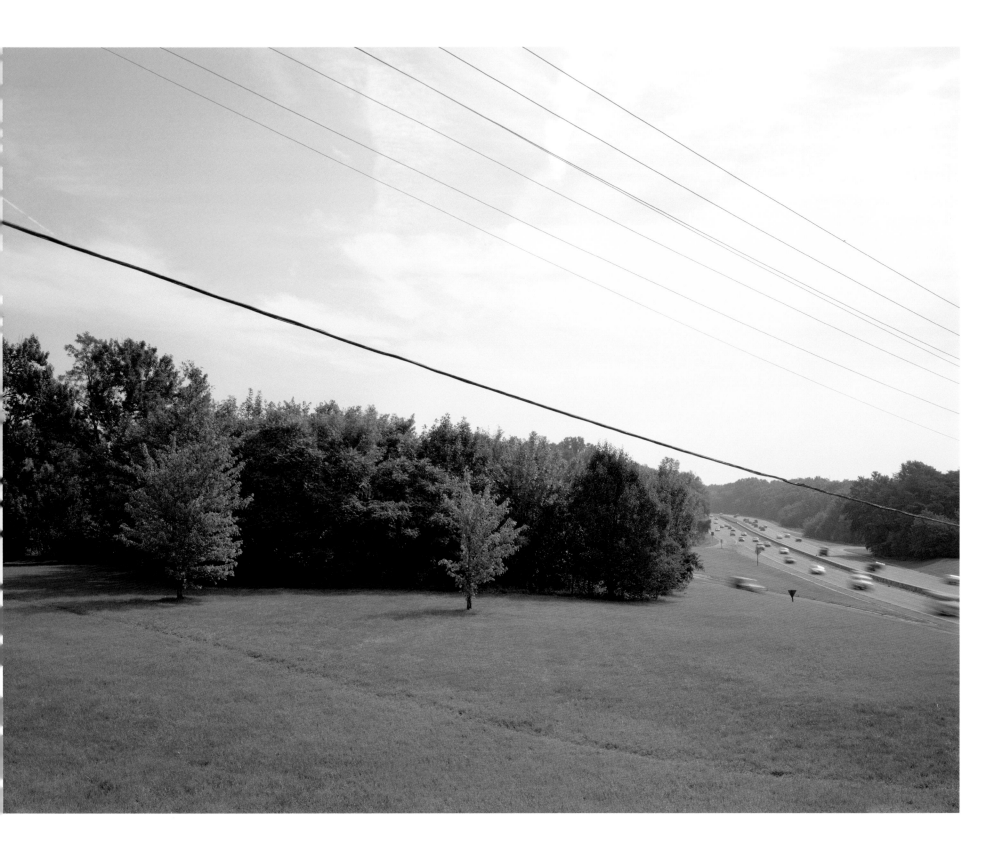

Man in Woods
GREENBELT, MARYLAND

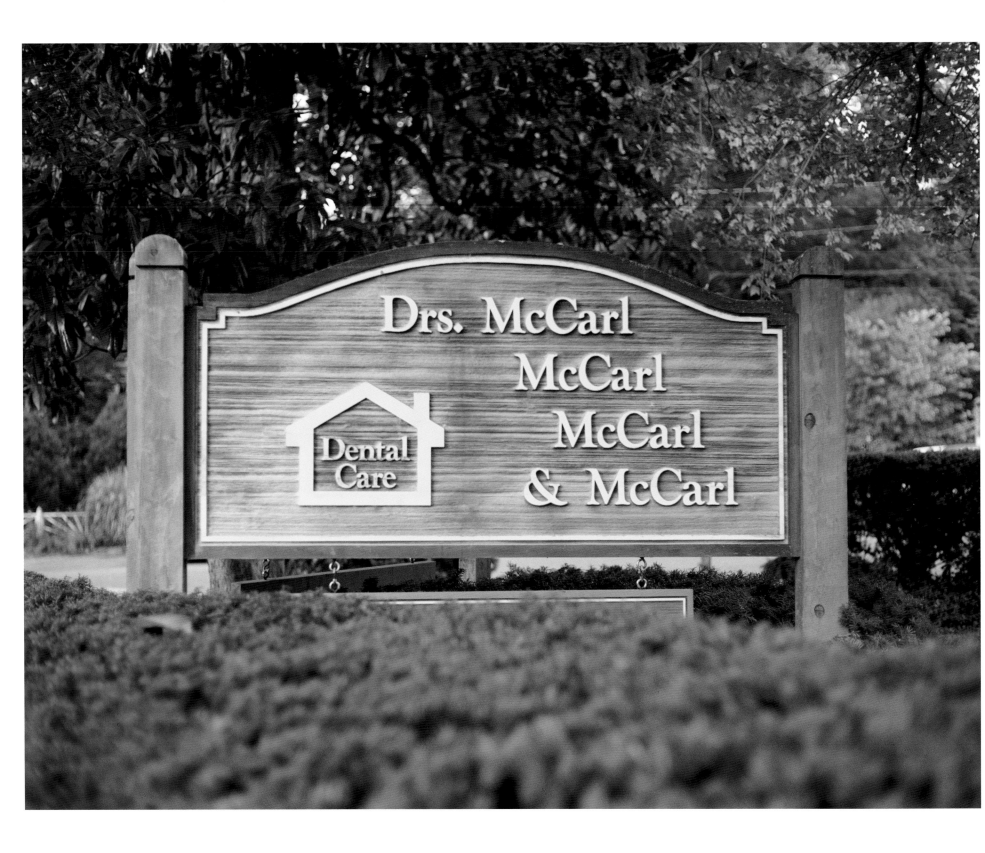

Drs. McCarl
GREENBELT, MARYLAND

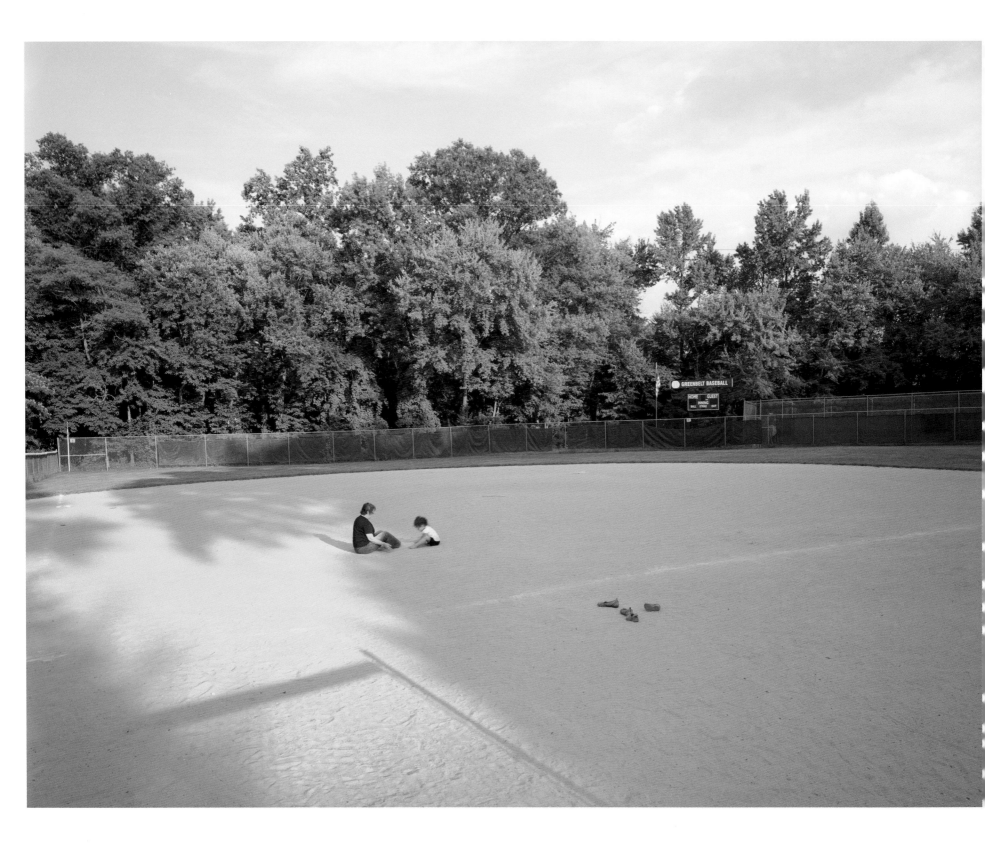

Baseball Field
GREENBELT, MARYLAND

" ORDER HAS COME; order and life together. We've got the skill, we've found a way, we've built the cities. All that we know about machines, and soils and raw materials, human ways of living is waiting. We can reproduce the pattern and better it a thousand times. It's here: the new city, ready to serve a better age, you and your children. The choice is yours. **"**

LEWIS MUMFORD,
commentary from the documentary film *The City,* featured at the *City of Tomorrow* exhibit in the 1939 World's Fair in New York

Woods and Apartment
GREENBELT, MARYLAND

Water Tower and Shrubs
GREENDALE, WISCONSIN >

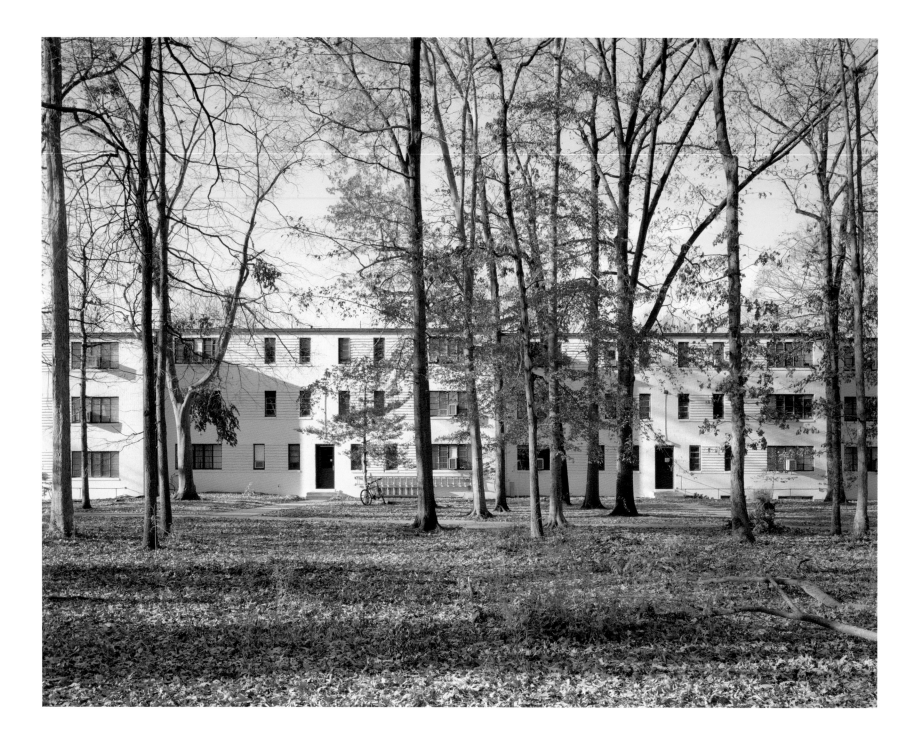

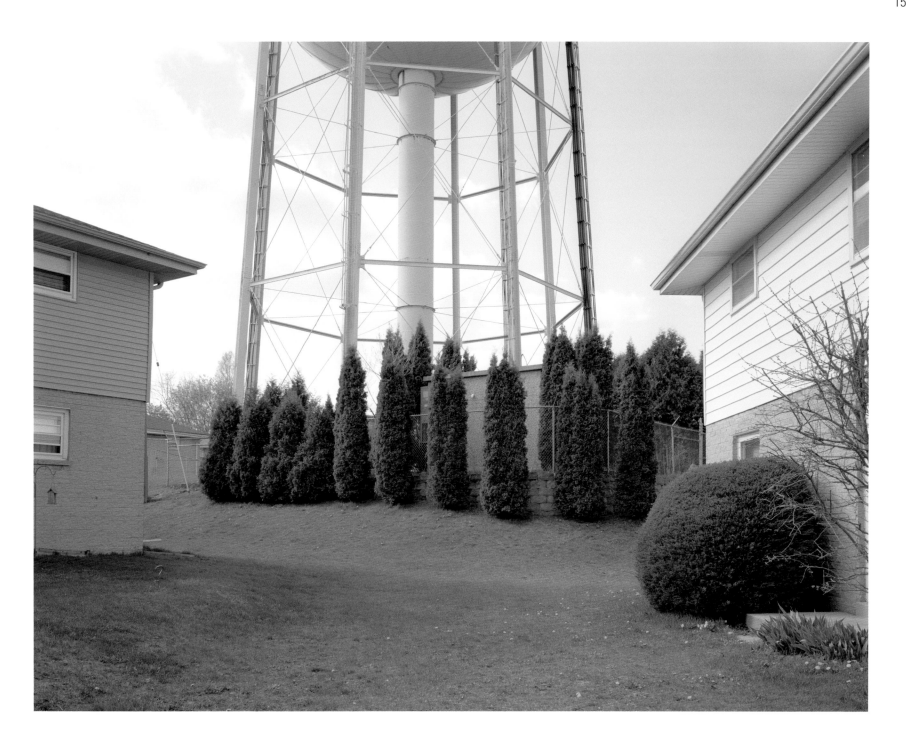

Library
GREENHILLS, OHIO

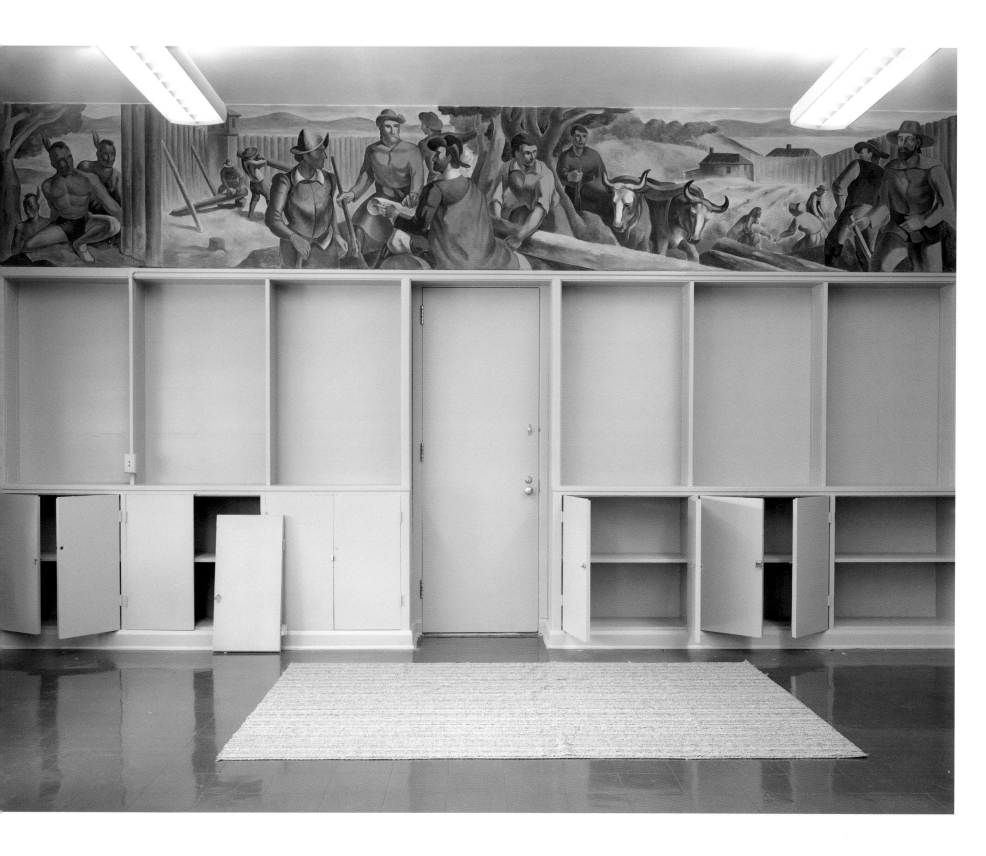

Mother and Child
GREENBELT, MARYLAND

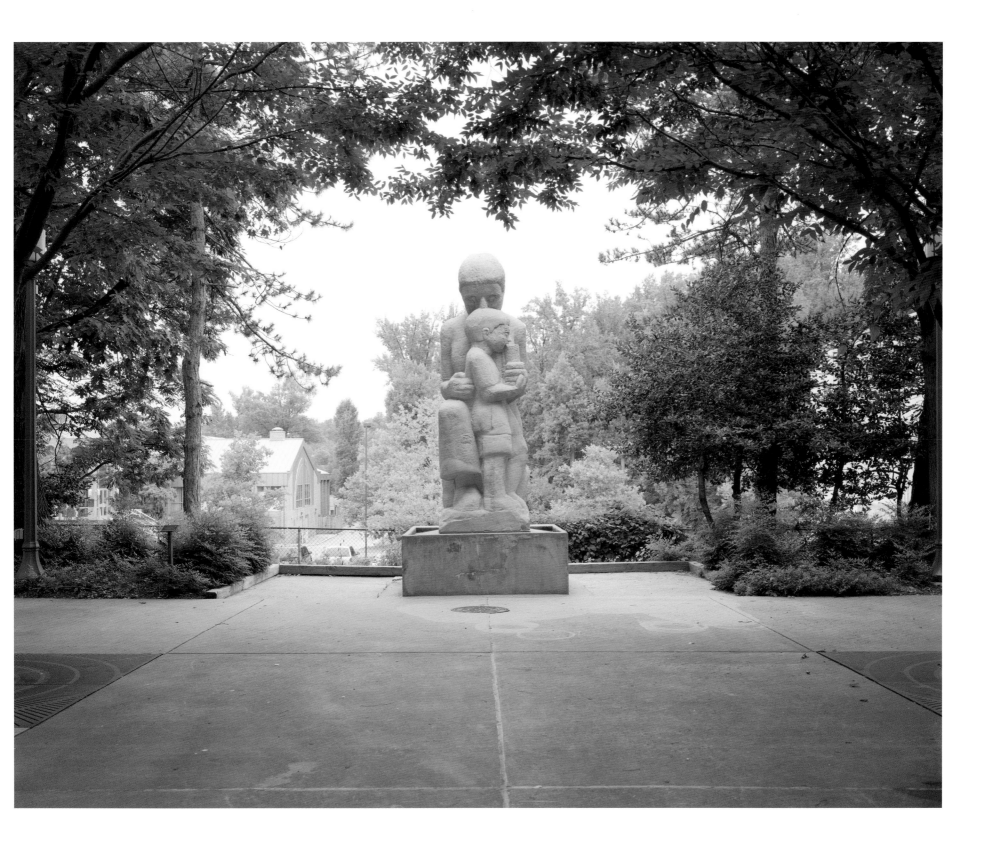

Cover of *Greenbelt Towns, a Demonstration in Suburban Planning*, 1936

AMERICA'S GARDEN CITIES

ROBERT LEIGHNINGER, JR.

When Thomas More coined the word *Utopia* in 1516 to describe a fictional island society, the Greek words he put together meant "no place," but the word's homophonic Greek prefix could also mean "good place." Utopias can be fictional, but they can also provide models for an ideal world, and with faith and hard work they might be made real. Jason Reblando's photographs of the Greenbelt Towns evoke not only Rexford G. Tugwell's faith in and hard work for a utopian society, but also the frayed edges of an unachievable ideal world, and that utopia is in fact, "no place."

Real utopia building has a proud if occasionally troubled tradition in the United States and the United Kingdom. In the late eighteenth and early nineteenth centuries, new religious sects that were different enough in theology and social practices that they did not fit easily into the mainstream began to build their own good places on the frontier. The Shakers, the Mormons, and the Perfectionists were the first to break away. The Shakers were celibate, the Mormons were polygamous, and the Perfectionists, most scandalous of all, mandated open sexual relations. Other groups that followed—the Rappites, Owenites, Icarians, and followers of Charles Fourier—were less socially radical, but still sought to form their own communities somewhere apart.

Company towns, another form of consciously building better places, were spawned by industrialism. Though their legacy has often been fraught with stories of exploitation and poverty, some were indeed better places to live. Robert Owen reduced hours and raised wages in his cotton mill town in New Lanark, Scotland. Titus Salt's Saltaire in Wales provided housing, schools, recreation facilities, and hospitals for the workers of his textile factory. George Cadbury's Bournville, in England, was recognized as a town with an innovative design that allowed for vast tracts of shared green spaces that became a model for other suburban areas throughout England.

While those towns incorporated small scale planning, the Garden City movement that began in England was much more ambitious. It was inspired not just by a desire

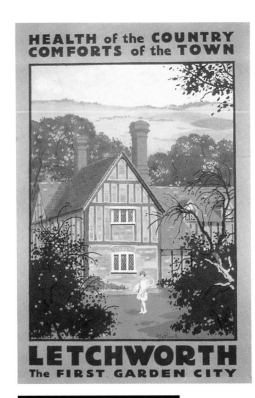

HEALTH of the COUNTRY
COMFORTS of the TOWN

LETCHWORTH
The FIRST GARDEN CITY

Postcard from Letchworth, England

to escape crowded, smoky, disease-ridden cities—though that was certainly a driving force—but more important, by the desire to find a place where work and daily life could be integrated in an environment of natural beauty. In his 1898 publication *To-Morrow: A Peaceful Path to Reform*, Sir Ebenezer Howard proposed creating new, self-contained cities with farms, green spaces, factories, and homes planned on a human scale. Howard envisioned Garden Cities that would contain the best of town and country, fresh air and sunlight, the stimulation of community, and easy access to work. In fact, this design bears a strong resemblance to More's *Utopia*, which offers a similar balance of town and country.[1]

Howard was not only a visionary but also a dynamic planner by nature, and he wasted no time in bringing his utopian ideas to fruition. In 1899, he formed the Garden City Association, which financed and built the first such city north of London, Letchworth Garden City, in 1903, designed by Raymond Unwin and Barry Parker. Howard founded a second garden city fifteen miles away, Welwyn Garden City, after World War I in 1920. The movement spread to America where planners and architects Clarence Stein and Henry Wright designed Radburn, New Jersey, along garden city lines in 1929, with design amenities, such as houses on cul-de-sacs, careful landscaping, and walkways and peripheral traffic patterns that prioritized the safety of pedestrians.

The Garden City model took on an added symbolic force in the United States during the Great Depression, when urban planners sought to create alternatives to the increasingly desperate living conditions of the urban poor and displaced farmers. Thousands of families were farming barren land, getting swept off their farms in the Dust Bowl, or becoming stranded where sources of income had dried up. Rural populations were migrating towards industrial jobs in urban centers since the late nineteenth century, but by the 1920's and '30s, when new arrivals to the city were looking for employment, they encountered bad housing, overcrowding, sickness, and pollution. After the stock market crash of 1929, the focus of American planning expanded from the city and state levels to nationwide efforts. Large-scale slum clearance and community building projects became cornerstones of New Deal recovery programs.[2]

Rexford G. Tugwell, part of Franklin Roosevelt's "Brain Trust," proposed the construction of new, self-sustaining cities modeled upon Garden City principles. Inspired by the work of Ebenezer Howard, Tugwell would use the newly created New Deal agency, the Resettlement Administration (RA), as a laboratory for testing his ideas on land ownership and social organization. The RA built farming communities and migrant camps, and took over the subsistence homestead program from the Public Works Administration. The Greenbelt Towns themselves, built under the auspices of the Suburban Resettlement Division, were the New Deal's most ambitious undertaking, on the

[1] Frederick F. Osborn, *Green-Belt Cities* (New York: Schocken, 1971), pp. 172–174.

[2] For more on this phenomenon, see: William H. Mullins, *The Depression and the Urban West Coast, 1929–1933: Los Angeles, San Francisco, Seattle, and Portland* (Bloomington: Indiana University Press, 2000) and Eugenie L. Birch, "Radburn and the American Planning Movement," in: *Journal of the American Planning Association*, 46.4 (October 1980), pp. 424–431.

scale of the Tennessee Valley Authority (TVA). With a zeal for change, Tugwell envisioned model cities that would reabsorb the wandering jobless exiles from both farm and city into a more humane environment replete with open green spaces, belts of surrounding parks and farmland to prevent cities from growing too large, and architecture that fostered a sense of community. The RA enlisted Radburn planners Stein and Wright, as well as TVA's Roland Wank and housing expert Catherine Bauer to create these utopian communities. They set to work with great energy.[3]

In Tugwell's vision, the Greenbelt Towns would span the United States and welcome low-income families; unfortunately, these hopes were compromised almost immediately. The RA was in a budget squeeze from its inception, and the program's aspirations were continually scaled back. Four sites had been selected from an initial list of one hundred to be Greenbelt cities—Greenbelt, Maryland, located northeast of Washington, D.C.; Greenhills, Ohio, located north of Cincinnati; Greendale, Wisconsin, located southwest of Milwaukee; and Greenbrook, in southern New Jersey. Greenbrook had to be cancelled because property owners threatened suit against the whole resettlement program. With an appropriation of only $31 million, they had to build five thousand units, which was eventually scaled back to 3,500. Roland Wank, who had managed bigger budgets for the TVA, thought they would succeed "if nothing unforeseen" arose. He added, however, "that it would be an unforeseen circumstance if nothing unforeseen occurs."[4]

The unforeseen occurrences were already arriving in the forms of unskilled labor and inclement weather. The WPA commissioner for the Washington, D.C. area sent 1,500 relief workers to Greenbelt the day after the program was announced. Blueprints were not ready, so they were put to work digging a lake without the use of earth-moving machines. This lake was hardly a key part of the town, but it was something that unskilled workers could undertake. The winter of 1935–36 froze the ground to a depth of fourteen inches and covered it with ten-foot snow drifts, hampering construction. The following winter and spring brought heavy rains, and a devastating flood causing further delays.[5]

The program was continually threatened by budget constraints and construction delays. A stringent budget required cuts in the number of houses, but the utilities and other amenities like schools had to be constructed based on the original plan so that when the other units were built later, there would be infrastructure to support them. This, in turn, raised the unit cost of housing considerably.[6] Because of the need to absorb the multitude of unskilled relief workers, use of machinery was purposefully limited, making progress slow and more

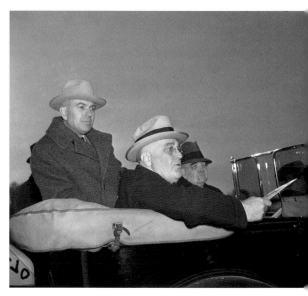

RA Administrator Rexford Tugwell (left), President Franklin D. Roosevelt, and RA Deputy Administrator Will Alexander in Greenbelt, Maryland, 1937

3 Joseph L. Arnold, *The New Deal in the Suburbs: A History of the Greenbelt Town Program, 1935–1954* (Columbus: Ohio State University, 1971), pp. 29–30, 46–50, 85.
4 Ibid., pp. 88–89.
5 Arnold, *The New Deal in the Suburbs*, pp. 61–74, 112, 116–117; Leta Mach, "Constructing the Town of Greenbelt" in: *Greenbelt: History of a New Town, 1937–1987*, ed. Mary Lou Williamson (Norfolk, VA: Donning, 1987), p. 33; Daniel Schaffer, "Resettling Industrial America: The Controversy Over FDR's Greenbelt Town Program," in: *Urbanism Past and Present* 15.8 (Winter/Spring 1983), pp. 18–32.
6 Arnold 1971 (see note 3), pp. 90–91, 95–96, 98; Cathy D. Knepper, *Greenbelt, Maryland: A Living Legacy of the New Deal* (Baltimore: Johns Hopkins University Press, 2001), p. 21.

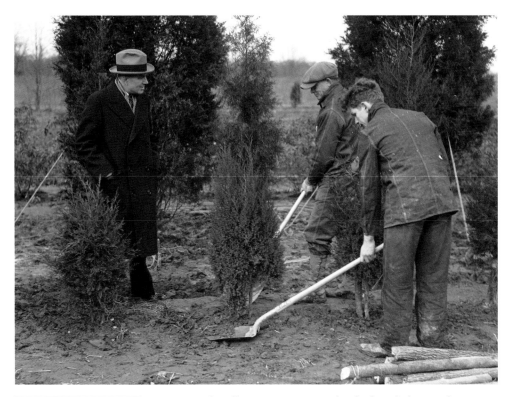

Resettlement Administrator Tugwell in Berwyn, Maryland, 1935

expensive. Basements were dug by hand. An earthen ramp was used instead of cranes to get material to the roof of the Greenbelt theater. Horse-drawn wagons were used in Greendale. Frustrated, Tugwell expected they might next be forced to dig with spoons. It was estimated that $5 million could have been saved by using more machinery. They could not meet the 1936 completion date that President Roosevelt had originally set, but the cities were eventually completed. Greenbelt opened in the fall of 1937, and Greenhills and Greendale opened in early 1938.[7]

The RA constructed 885 of the revised goal of 1,000 units in Greenbelt, in Greenhills 676 of 1,000, and in Greendale 572 of the planned 750. The Greenbelt Towns did follow Garden City principles. The roads followed the contour of the land with many of the residential streets ending in cul-de-sacs. In general, automobile traffic was kept to the

periphery and many homes faced inward to parks or play areas for children. In Greenbelt, Maryland, pedestrian underpasses allowed families and children to walk to the shopping center or school without crossing the major traffic artery. The Greenbelt community center doubled as an elementary school and included a swimming pool and athletic field. The shopping center had a movie theater. Community facilities in the other towns were similar. Greendale, Wisconsin, included farms, and its shopping area resembled a traditional small town with a main street rather than a pedestrian mall.[8] Greenhills, Ohio, is surrounded by a natural boundary of forest and parks.

Regardless of the controversies surrounding the construction of these communities, plenty of people wanted to live in the Greenbelt Towns, even if it meant being screened by government workers. They had to meet specific income qualifications—needy enough to fit the RA's aid goals, but wealthy enough to afford the higher rents that congressional budgets made necessary. Beyond this, however, the RA also sought residents who were willing to participate in the social and political life of a cooperative community. Between the social organization and the state ownership of the property, these traits raised the specter of socialism in the minds of the critics of the New Deal. One newspaper headline announced these government suburbs were the "First Communist Towns in America."[9]

The new residents plunged into community life with gusto. There were organizations and clubs for everything imaginable, so much so that an official "stay-at-home week"

7 Arnold 1971 (see note 3), p. 115; Mach 1987 (see note 5), pp. 32–33.

8 Paul K. Conkin, *Tomorrow a New World: The New Deal Community Program* (Ithaca: Cornell University Press, 1959), pp. 311–315; Mach 1987 (see note 5), pp. 35–36.

9 Daniel T. Rodgers, *Atlantic Crossings: Social Politics in a Progressive Age* (Cambridge: Harvard University Press, 1998), p. 469.

had to be declared in December, during which no meetings could be scheduled.[10] More threatening to critics were the consumer cooperatives set up in the Greenbelt Towns. Groceries, drugs, even haircuts were available through cooperative enterprises, in which community members held stock. There was even a "gum drop co-op" for elementary school students for buying candy and school supplies. The economic fortunes of the co-ops waxed and waned. Many of the co-operative businesses failed; however, a recent study of Greenbelt, Maryland, reports that the spirit of cooperation and community involvement continues to survive. The historic core of row houses in Greenbelt exists as a cooperative called Greenbelt Homes, Inc.[11]

Tugwell's controversial ideas became a political liability for Roosevelt. He resigned from the RA in 1936, and the RA was absorbed into the Farm Security Administration. With the completion of the towns in 1938, the Suburban Resettlement Division was abolished. In 1942, the towns were transferred to the U.S. Public Housing Authority. Always uncomfortable with this form of government land ownership, Congress began pushing in earnest for a sell-off in 1947. Various non-profit tenant and veterans groups managed to buy parts of the towns, other parts were sold at auction, public facilities were sold to local governments, and the liquidation was complete by 1954.[12] Sadly, the natural boundary of forestland in Greenbelt would eventually be devoured by private developers and highways.

Despite their challenges, the Greenbelt communities remain as one of the finest examples of New Deal public works and a worthy long-range public investment, both in spirit and structure. According to Paul Conkin: "The greenbelt towns remain the grandest monuments of Rexford G. Tugwell's work in the Resettlement Administration. In [...] the field of public works they were hardly excelled, even by the Tennessee Valley Authority, in imagination, in breaking with precedents, and in broad social objectives. They represented, and still do represent, the most daring, original, and ambitious experiments in public housing in the history of the United States."[13]

There are many fine books that have been written about the history of the Greenbelt Towns, but no one has provided a visual examination of all three communities in the same way Jason Reblando has in *New Deal Utopias*. These photographs act not only as records of the towns almost eighty years after their founding, but also hint at the Garden of Eden, Puritan John Winthrop's call to be "a City upon a Hill," and America's pioneering spirit. With an intense curiosity about the intersection of politics and place, where utopian thought often resides, Reblando's photographs are a complex visual homage to Tugwell's dream made real. They should give us pause to consider the lives, politics, and spaces of all communities, whether they are planned or unplanned.

[10] Conkin 1959 (see note 8), pp. 316–319; Barbara Likowski and Jay McCarl, "Social Construction," in: Williamson (see note 5), pp. 71–80.

[11] Arnold 1971 (see note 3), pp. 173–177, 180–185; Knepper 2001 (see note 6), p. 183.

[12] Arnold 1971 (see note 3), pp. 229–238; Conkin 1959 (see note 8), pp. 322–325.

[13] Conkin 1959 (see note 8), p. 305.

1. Blueprint, Greenbelt, Maryland, 2010

2. Daffodil House, Greendale, Wisconsin, 2009

3. Frieze, Greenbelt, Maryland, 2010

4. Microfiche, Greenbelt, Maryland, 2009

5. Roosevelt Baseball Players, Greenbelt, Maryland, 2009

6. Winton Woods, Greenhills, Ohio, 2009

7. Mushroom, Greenbelt, Maryland, 2009

8. Townhouse, Greendale, Wisconsin, 2009

9. Clothesline, Greenbelt, Maryland, 2009

10. Garden Community, Greendale, Wisconsin, 2009

11. More Details, Greenbelt, Maryland, 2009

12. Gazebo, Greendale, Wisconsin, 2009

13. Tree Shade, Greenbelt, Maryland, 2009

14. Underpass, Greenbelt, Maryland, 2009

15. Farragut House, Greenhills, Ohio, 2010

16. Veteran Pictures, Greenhills, Ohio, 2010

17. Greenbelt Lake, Greenbelt, Maryland, 2010

18. Woman in Study, Greenbelt, Maryland, 2009

19. City Hall, Greenbelt, Maryland, 2009

20. Wheat Room, Greendale, Wisconsin, 2010

21. Rockclimb, Greendale, Wisconsin, 2010

22. Living Room Garden, Greenbelt, Maryland, 2009

23. Garden Cloth, Greenbelt, Maryland, 2009

24. Village Hall, Greendale, Wisconsin, 2009

25. Tree Crutch, Greenbelt, Maryland, 2009

26. Teens in Front of Community Center, Greenbelt, Maryland, 2009

27. Anniversary Pennants, Greenhills, Ohio, 2010

28. Glass Block Houses, Greenbelt, Maryland, 2010

29. Car Cover, Greenbelt, Maryland, 2009

30. Basketball Court, Greenhills, Ohio, 2009

31. Lake, Greenhills, Ohio, 2009

32. Man with Pocket Protector, Greenbelt, Maryland, 2009

33. Archery Target, Greenhills, Ohio, 2010

34. Girl Raking Leaves, Greenbelt, Maryland, 2010

35. Quilt, Greenbelt, Maryland, 2009

36. Boy Washing Car, Greendale, Wisconsin, 2009

37. Gym Seats, Greenhills, Ohio, 2010

38. Winter Houses, Greenbelt, Maryland, 2010

39. Music Room, Greenhills, Ohio, 2010

40. House Tour, Greendale, Wisconsin, 2009

41. Teen with Compost, Greenbelt, Maryland, 2009

42. Gym, Greenhills, Ohio, 2010

43. Woman in Backyard, Greenbelt, Maryland, 2009

44. Mailbox, Greendale, Wisconsin, 2009

45. Converging Paths, Greenbelt, Maryland, 2010

46. Rockwell Covers, Greendale, Wisconsin, 2009

47. Wall Grid, Greenhills, Ohio, 2009

48. Hauser Sculpture, Greendale, Wisconsin, 2009

49. Park Hazard, Greenhills, Ohio, 2010

50. Compost, Greenbelt, Maryland, 2009

51. Pennant Flags, Greenhills, Ohio, 2010

52. Woman in Woods, Greenbelt, Maryland, 2009

53. Office Park, Greenbelt, Maryland, 2011

54. Park Stage, Greenbelt, Maryland, 2009

55. Brook, Greendale, Wisconsin, 2010

56. Village Hall Desk, Greendale, Wisconsin, 2010

57. Man with Fishing Poles, Greenhills, Ohio, 2010

58. Greenbelt Lake, Greenbelt, Maryland, 2009

59. Parade, Greendale, Wisconsin, 2010

60. Morning Fog, Greenbelt, Maryland, 2010

61. Gutter and Shadow, Greendale, Wisconsin, 2011

62. Church, Greenbelt, Maryland, 2010

63. Stone Animals, Greenhills, Ohio, 2009

64. Clinging Vine, Greenhills, Ohio, 2009

65. Swing and Shrubs, Greenbelt, Maryland, 2010

66. Water Tower, Greendale, Wisconsin, 2010

67. Hooray 4 Co-Ops, Greenhills, Ohio, 2009

68. Boys on Bikes, Greenhills, Ohio, 2009

69. Greenbelt Theatre, Greenbelt, Maryland, 2010

70. Disney Garages, Greendale, Wisconsin, 2009

71. Forest Path, Greendale, Wisconsin, 2011

72. Tree and Highway, Greenbelt, Maryland, 2009

73. Man in Woods, Greenbelt, Maryland, 2010

74. Drs. McCarl, Greenbelt, Maryland, 2009

75. Baseball Field, Greenbelt, Maryland, 2009

76. Woods and Apartment, Greenbelt, Maryland, 2010

77. Water Tower and Shrubs, Greendale, Wisconsin, 2010

78. Library, Greenhills, Ohio, 2009

79. Mother and Child, Greenbelt, Maryland, 2010

Photos in Essays

1. Greenbelt, Maryland, 1939, Fairchild Aerial Survey. Courtesy of the Library of Congress, Prints & Photographs Division, FSA/OWI Collection, LC-USF344- 007483-ZB

2. Senior prom in Greenbelt, Maryland, 1942. Marjory Collins. Courtesy of the Library of Congress, Prints & Photographs Division, FSA/OWI Collection, LC-USW3-003463-E

3. Carpenter in Greenbelt, Maryland, 1936. Carl Mydans. Courtesy of the Library of Congress, Prints & Photographs Division, FSA/OWI Collection, LC-USF33- 000690-M3

4. Cover of *Greenbelt Towns, a Demonstration in Suburban Planning. Washington, D.C.: Resettlement Administration*, 1936

5. Postcard from Letchworth, England

6. President Roosevelt, Administrator Tugwell (left) and Dr. Alexander in Greenbelt, Maryland, 1937. Courtesy of the Library of Congress, Prints & Photographs Division, FSA/OWI Collection, LC-USF34- 015446-C

7. Resettlement Administrator Tugwell in Berwyn, Maryland, 1935. Elmer Johnson. Courtesy of the Library of Congress, Prints & Photographs Division, FSA/OWI Collection, LC-USF34- 001339-D

ACKNOWLEDGMENTS

This book, like the spirit of the Greenbelt Towns, is the result of a collective effort.

I would like to thank Natasha Egan and Robert Leighninger, Jr. for their thoughtful essays, as well as Jason Pickleman for his elegant and bold book design. I am grateful for the guidance, patience, and expertise of everyone at Kehrer Verlag who made this book possible, including Alexa Becker, Daniel Sommer, Olivia Lederer, Martin Lutz, Barbara Karpf, Patrick Horn, Silke Küpperscheeg, and Klaus Kehrer.

I am humbled by the generous support of Charles Dee Mitchell, George and Margaret Pottanat, John Matosky, Kevin Kidder, Erik Gellman, Erik and Jennifer Nordman, Tracy Dillard, Dr. Christopher Cavagnaro, Eunice Yi and Jon Deitemyer, and David and Martha Moore of Pictura Gallery. The publication of *New Deal Utopias* was assisted by grants from the Puffin Foundation and the Associate Vice President for Research at Illinois State University. Thank you to Richard Walker, Susan Ives, and Gabriel Milner at the Living New Deal, which provided fiscal sponsorship for the project.

Drum scans and exhibition prints for *New Deal Utopias* were produced during an artist residency at LATITUDE Chicago. Thank you to James Pepper Kelly, Thom Dryzanski, Xander Fischer, Chelsea Goldberg, and Molly Brandt for their generosity during the residency.

173

I would like to thank the following for sharing *New Deal Utopias*: David Gonzalez, Jock Reynolds, Whitney Johnson, Tina Barney, Melissa Harris, Peter Barberie, Allison Peters Quinn, Nancy Levinson, Josh Wallaert, Iker Gil, Lisa Hostetler, Lisa Woodward, MiaDalglish, Lauren Kniss, Jason Peot, Kelly Clark, Nathan Mason, Daniel Schulman, Christine Frisinghelli, Ingrid Schaffner, Doug Stapleton, Andy Adams, Claire Hedden, Doug Johnson, Ian Carey, Kevin Tringale, Kevin Miyazaki, Michal Raz-Russo, Tricia Van Eck, Gregory Harris, Marcy Dinius, Kyohei Abe, Madeline Yale Preston, David Travis, Anni Holm, Nate Mathews, Nathaniel Coleman, Abigail Smithson, Steve Bisson, and the Filter Photo Festival.

Thank you to everyone at Columbia College Chicago who has supported my work, especially Bob Thall, Paul D'Amato, Judy Natal, Barbara Kasten, Kelli Connell, Greg Foster-Rice, Terry Evans, Tom Nowak, and Myra Greene. Sincere thanks to Karen Irvine, Allison Grant, Corinne Rose, Stephanie Conway, and Kristin Freeman for sharing this project through the Midwest Photographers Project at the Museum of Contemporary Photography, Chicago.

I am grateful for the friendship and feedback of David Oresick, Jennifer Ray, Kate Bowen, Allison Grant, Lisa Lindvay, Niki Grangruth, Heather Christoffer, Mike Reinders, Kevin Mallela, Jessica Rodrigue, Ethan Jones, Jay Turner Seawell, Nick Albertson, Josh Poehlin, Garrett Baumer, Justin Schmitz, Brian Ulrich, Colleen Plumb, Ian J. Whitmore, Amy Herman, Alyssa Marzolf, Barbara Diener, Julie Jones, Clarissa Bonet, Natalie Krick, Karl Baden, Rich Cahan, Jamie Kalven, Patricia Evans, David Eads, Michael Ensdorf, Bradford Hunt, Ann Jastrab, Cornelius Howland, Tim Campos, Alonso Nichols, Andrew Huot, Robb Hill, Bruce Myren, Leslie K. Brown, Nate Larson, Daniel Coburn, David Schalliol, Jin Lee, Bill O'Donnell, and Rhondal McKinney.

New Deal Utopias would not have been possible without the generosity of the residents and historical societies of Greenbelt, Maryland; Greenhills, Ohio; and Greendale, Wisconsin. Special thanks to Mary Sies, Sheila Maffay-Tuthill, Megan Searing Young, Glory Southwind, Kathleen Hart, and Ted Mainella who live the legacy of the New Deal every day. Thank you also to Margie Rung at the Center for New Deal Studies at Roosevelt University, Chicago, and Kathy Flynn at the National New Deal Preservation Association, Santa Fe.

I am especially indebted to Dawoud Bey for his ongoing encouragement, insight, and friendship.

Many thanks to my family, and above all to Joanne Diaz and our son Gus, for making my world ideal.

JASON REBLANDO

Jason Reblando is an artist and photographer based in Chicago and Bloomington, Illinois. He received his MFA in Photography from Columbia College Chicago, and a BA in Sociology from Boston College. He is the recipient of a Fulbright Fellowship to the Philippines and an Illinois Arts Council Artist Fellowship Award. He has served as a grant panelist for the National Endowment for the Arts and the City of Chicago Department of Cultural Affairs Community Arts Assistance Program. His work has been published in the *New York Times*, *Camera Austria*, *Slate*, *Bloomberg Businessweek*, *Real Simple*, *Chicago Magazine*, *the Chicago Tribune*, and *PDNedu*. His photographs are part of the collections in the Milwaukee Art Museum, the Museum of Contemporary Photography, Chicago, and the Philadelphia Museum of Art.

NATASHA EGAN

ROBERT LEIGHNINGER, JR

Since 2011, **Natasha Egan** has served as the executive director of the Museum of Contemporary Photography at Columbia College Chicago, where she was previously the associate director and curator since 2000. She has organized over fifty exhibitions with a focus on contemporary Asian art and artists concerned with societal issues, such as the environment, war, and economics. Egan has contributed essays to numerous publications and periodicals and lectures internationally.

Robert Leighninger, Jr. is a member of the Advisory Board of the National New Deal Preservation Association, Santa Fe; the Board of Directors of the National Jobs for All Coalition, Lynbrook, New York; and a Project Adviser to The Living New Deal Project, Berkeley, California. Though trained as a sociologist, he has been immersed in the history of New Deal public works for the past 20 years. He is the author of *Long-Range Public Investment: The Forgotten Legacy of the New Deal* (University of South Carolina Press, 2007) and *Building Louisiana: The Legacy of the Public Works Administration* (University Press of Mississippi, 2007), which won the Abel Wolman Award for best book on public works history given by the Public Works Historical Society, American Public Works Association.

© 2017 Kehrer Verlag Heidelberg Berlin, Jason Reblando, and authors

Texts: Natasha Egan, Robert Leighninger, Jr.

Copy Editing: Joanne Diaz

Proofreading: Gérard A. Goodrow

Design: The JNL Graphic Design, Chicago

Image Processing: Kehrer Design Heidelberg (Patrick Horn)

Production: Kehrer Design Heidelberg (Silke Küpperscheeg)

Front Cover: *Parade, Greendale, Wisconsin*, 2010

Back Cover: *Underpass, Greenbelt, Maryland*, 2009

Endpapers: Detail of Greenbelt, Maryland, town plan illustration, *Greenbelt Towns, a Demonstration in Suburban Planning*, Resettlement Administration, Washington, D.C., 1936

Excerpt from "A Speech to the Garden Club of America": Copyright © 2010 by Wendell Berry, from *Leavings: Poems*. Reprinted by permission of Counterpoint.

Bibliographic information published by the Deutsche Nationalbibliothek: The Deutsche Nationalbibliothek lists this publication in the Deutsche Nationalbibliografie; detailed bibliographic data is available on the Internet at http://dnb.dnb.de.

Printed and bound in Germany

ISBN 978-3-86828-790-5

Kehrer Heidelberg Berlin
www.kehrerverlag.com

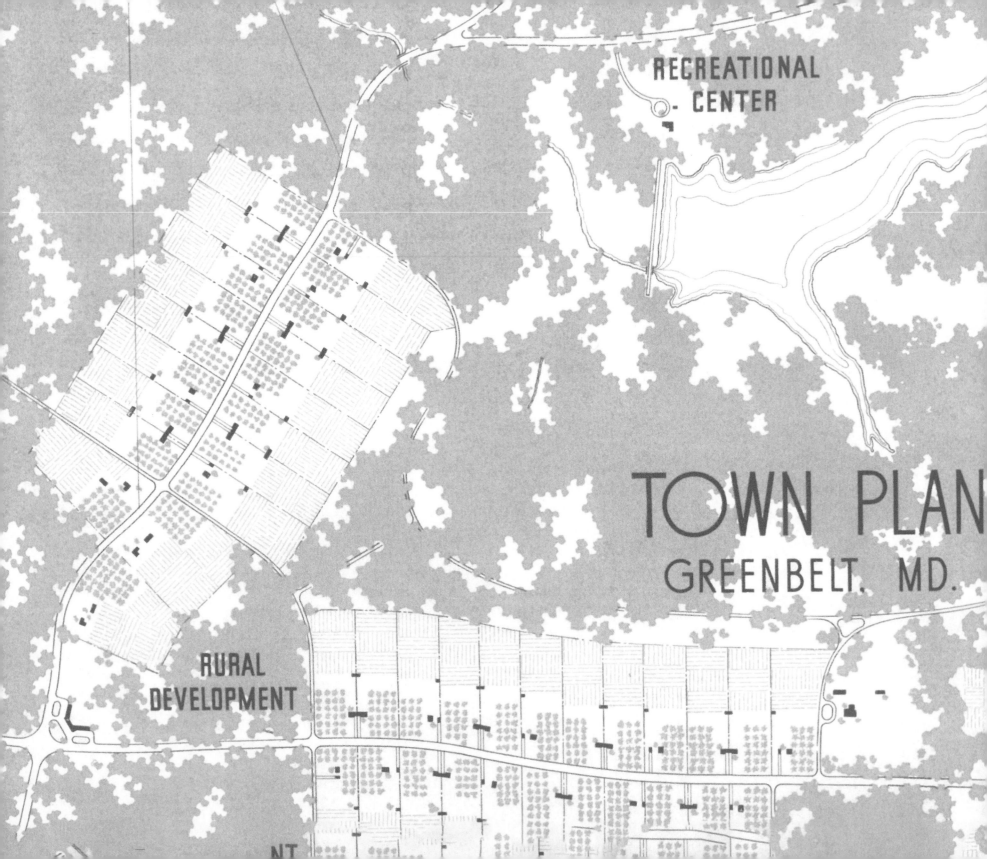

RECREATIONAL
CENTER

TOWN PLAN

GREENBELT, MD.

RURAL
DEVELOPMENT